THEY SAID IT!

THEY SAID IT!

An Anthology of Wit

AUBREY MALONE

First published December 2024

© Aubrey Malone

The author asserts his moral right to be identified as the author of the work.

All rights reserved. No part of this publication may be reproduced, stored in a retrieval system or transmitted in any form or by any means, electronic, mechanical, photocopying, recording or otherwise, without the prior permission of the publishers

ISBN 978-1-913144-67-8

Cover:

PENNILESS PRESS PUBLICATIONS
Website:www.pennilesspress.co.uk/books

CONTENTS

Introduction 4

Self-Criticism 5

Hollyweird 9

Men and Women 13

Food and Weight 15

Sex 17

Clothing 20

Sport 22

Marriage 25

Playing With Sayings 27

Animals 30

Literature 34

Politics 40

Foot in Mouths 46

Non-Sequiturs 48

Advice 52

Money 56

People and Places 58

Music 60

Religion 64

Children 67

The Law 70

Cunning Linguists 72

Art 76

Love 78

Age 81

Graffiti 84

A Penn'orth of Allsorts 87

Introduction

The French have an expression called *l'esprit de l'escalier* – the spirit of the staircase. It refers to the remark you thought of on the staircase from the room you were in, where all the witty rejoinders were flying and you stood mute and uninspired in the melee.

This book should give you enough verbal ammunition to prevent such scenarios unfolding in the future. It contains the wit and wisdom of Quotable Notables, people who have espied the foibles and eccentricities of the human animal at work and play and come to some rather quirky conclusions about him/her.

In my selection, gleaned from hours spent picking the brains of those more razor-sharp (and vitriolic) than I, I've placed the emphasis on economy of thought and word. These catchers in the wry generally cut to the chase.

Some of the quotations are funny, some are profound, and some are both. You don't have to agree with the sentiments expressed to enjoy them but I hope they will evince a reaction from you, either persuading you to agree with them (perhaps against your will) or rail vehemently against the sentiments they espouse.

They're the responses of colourful people to a sometimes absurd life, a worm's eye view of existence from the bruised, the battered and the bewildered.

SELF-CRITICISM

You could put all the talent I had into your left eyelid and still not suffer from impaired vision. (Veronica Lake)

There are three signs of old age. First you forget names, then you forget faces, and then … I can't remember the third one. (Red Skelton)

I'm nobody's fool. They couldn't find anyone to adopt me. (Emo Philips)

The last time I was inside a woman was when I visited the Statue of Liberty. (Woody Allen)

All I heard when I was growing up was, 'Why can't you be more like your cousin Sheila? Why can't you be more like your cousin Sheila?' Sheila died at birth. (Joan Rivers)

I'm a chartered accountant, but don't tell my parents. They think I'm playing the piano in a brothel. (Bruce Marshall)

It's easy to give up smoking. I've done it hundreds of times. (Mark Twain)

I'd kill for a Nobel Peace Prize. (Steven Wright)

My memory is starting to go. I locked the keys in the car the other day. Fortunately, I had forgotten to get out first. (Gene Perret)

I smoke in moderation: only one cigar at a time. (Mark Twain)

If my films make just one more person miserable, I'll feel I've done my job. (Woody Allen)

If *Jupiter's Darling* had been my first picture, there wouldn't have been a second. (Esther Williams)

I won an Oscar once for not dying. (Liz Taylor)

I love to smoke so much I'm going to have a tracheotomy so I can have two at the same time. (Denis Leary)

My children never forgave me. Oedipus only killed his father and married his mother, but I sold their Nintendo. (Sue Arnold)

I never had illusions about being a beauty – I was the only 17 year old character actress in movies. (Angela Lansbury)

Last night I was lying in bed with the wife. I was lying to her and she was lying to me. (Brendan Grace)

I like to drive with my knees. Otherwise how can I put on my lipstick and talk on the phone? (Sharon Stone)

Acting isn't very hard. The most important things are to be able to laugh and cry. If I have to cry, I think about my sex life. If I have to laugh, I think about my sex life. (Glenda Jackson)

With a nose as big as mine, cocaine would be a very expensive habit. (Chris de Burgh)

My best friend and I get along like brothers. Cain and Abel. (Gene Perret)

Appearing on the Simpsons is about the only thing I've done in my life that my kids have considered worthy of comment. (Tony Blair)

I think I failed my driving test. I'm waiting to hear … when the examiner gets out of hospital. (Phyllis Diller)

My father was the town drunk. Usually that's not so bad, but … New York? (Henny Youngman)

I had her in my bed gasping for breath and calling out my name. Obviously I didn't hold the pillow down long enough. (Emo Philips)

In high school my acne was so bad, blind people tried to read my face. (Joan Rivers)

I *was* a poster child – for birth control. (Rodney Dangerfield)

My hometown is so dull, the drugstore sells picture postcards of other towns. (Milton Berle)

The first time I tried to get a movie made in Hollywood my agent said to me, 'There are 'yes' lists and 'no' lists and you aren't even on the 'no' list.' (Alain Rudolph)

My films are so bad, they only show them in prisons and airplanes. That way nobody can leave. (Burt Reynolds)

I'm not an old-fashioned romantic. I believe in love and marriage, but not necessarily with the same person. (John Travolta)

My pessimism goes to the point of suspecting the sincerity of other pessimists. (Jean Rostand)

In Hollywood, if you can't sing or dance, you wind up as an after-dinner speaker. (Ronald Reagan)

I'm Jewish. I don't work out. If God had wanted us to bend over, He'd put diamonds on the floor. (Joan Rivers)

It's great to be 18. I can now legally do all the stuff I've been doing since I was 14. (Mitch Donohue)

Being the best divorce lawyer in New York is like being the best devil in hell. (Judith Regan)

My uncle's dying wish was to have me sitting in his lap. He was in the electric chair at the time. (Rodney Dangerfield)

I wanted to be a sex maniac but I failed the practical. (Robert Mitchum)

I got thrown out of Alcoholics Anonymous because when the other guys saw me, they thought they were having the DTs. (Dave Dutton)

I'm one of the few males who suffers from penis envy. (Woody Allen)

I could never understand income tax. (Albert Einstein)

If I ever had twins, I'd use one for parts. (Steven Wright)

I'm not prejudiced. I hate everyone equally. (W.C. Fields)

We sleep in separate rooms, we have dinner apart, we take separate vacations. We're doing everything we can to keep our marriage together. (Rodney Dangerfield)

When I was young I used to think I was indecisive but now I'm not so sure. (Mort Sahl)

I'm so unlucky, if Dolly Parton had triplets, I'd be the one on the bottle. (Mel Brooks)

Dentopadalogy is the science of opening your mouth and putting your foot in it, a science which I have practised for a good many years. (Prince Charles)

I made a lot of movies early in my career in the hope that I would become a star before people realised I couldn't act. (Michael Caine)

No one ever expects a great lay to pay the bills. (Jean Harlow)

I've done commercials in Australia I'd pay *not* to see. (John Cleese)

Someone cruelly pointed out in print that I looked like an unmade bed. (Dylan Thomas)

I'm so bad I make medicine sick. (Muhammad Ali)

I'm a sonofabitch. Plain and simple. (Kirk Douglas)

The other day I read in a newspaper that 82% of men would rather sleep with a goat than me. (Sarah Ferguson)

Often when I was making love to women in the past, I was conducting a business deal inside my head. (Arnold Schwarzenegger)

I reckon we're all made up of equal parts Rambo and Lucille Ball. (Boy George)

I wasn't abused in the industrial school in Artane, but I've heard so many stories of boys who were, I'm beginning to feel like a reject. (Brian Behan)

I was classified P4 by the draft board. In the event of war, I'm a hostage. (Woody Allen).

I'm not from the working class. I'm from the criminal class. (Peter O'Toole)

Don't tell my mother I work in an advertising agency. She thinks I play piano in a whorehouse. (Jacques Seguela)

I live in terror of not being misunderstood. (Oscar Wilde)

I'm the ugliest kid ever born. The doctor looked at me and said, 'She's not done yet', and shoved me back in. (Joan Rivers)

HOLLYWEIRD

Not to know him was to love him. (Bert Kalmar on producer Herman Mankiewicz)

I talked to a couple of yes men at Metro. They said no to me. (Billy Wilder)

As a sailor he was a damned good actor. (Michael Freedland on Jack Lemmon)

I was given a coach on the set of *Some Like It Hot*. I was playing a man dressed up as a woman so he said he would teach me how to walk like a woman, I told him I didn't want to walk like a woman. I wanted to walk like a man trying to walk like a woman. (Jack Lemmon)

Michael Caine compares himself to Gene Hackman. This is foolish. Hackman is an intimidating and dangerous actor. Mr Caine is about as dangerous as Laurel and Hardy, or indeed both, and as intimidating as Shirley Temple. (Richard Harris)

Otto Preminger is really Martin Bormann in elevator shoes with a facelift by a blindfolded plastic surgeon in Luxembourg. (Billy Wilder)

They put your name in a star in the sidewalk on Hollywood Boulevard. You walk down afterwards and find a pile of dog manure on it. That tells the whole story, baby. (Lee Marvin)

Cary Grant was an aloof, remote person intent on being Cary Grant playing Cary Grant playing Cary Grant. (Frances Farmer)

Tough? He was about as tough as Shirley Temple. (James Cagney on the off-screen Humphrey Bogart)

I thought only good guys got cancer. (Laurence Harvey on his deathbed at the age of 45 in 1974).

Groucho Marx had the compassion of an icicle and the generosity of a pawnbroker. (S.J. Perelman)

Went to see *Don't Look Now*. It was so boring I let my hand wander into the crotch of my companion and his only reaction was the line, 'Any diversion is welcome'. (Kenneth Williams)

Christmas is an annual three-day festival dedicated to the birth of Bing Crosby. (Willis Hall)

There's more sex appeal in Barbara Stanwyck's ankle bracelet in *Double Indemnity* than all those naked bodies rolling around on the screen today. (Bette Davis)

When he pushed that grapefruit in May Bush's face, Jimmy Cagney was epitomising one of the great mysteries of all time: Why do ladies prefer bastards? (Diana Dors)

Until you're known as a monster in my profession, you're not a star. (Bette Davis)

Surely no one but a mother could have loved Bette Davis at the height of her career. (Brian Aherne)

A director must be a politician, a psychoananayst, a sycophant… and a bastard. (Billy Wilder)

In Hollywood now when people die they don't say 'Did he leave a will?' but 'Did he leave a diary?' (Liza Minnelli)

When I went to see *Goldeneye* I was glued to my seat. Otherwise I would have left. (Dennis Penny)

Michael Caine can out act any – well, nearly any – telephone kiosk you care to mention. (Hugh Leonard)

No matter what you write in America, there's always talk of The Movie. You could write the Manhattan telephone directory and they'd say, 'So when is the movie?' (Frank McCourt)

It must be tough having a beautiful mother like Cher and being named Chastity. The only thing worse would be being beautiful and being called Slut. (Ava Gardner)

George Cukor played a very important part in my life. He was the first person to fire me. (Bette Davis)

At the start of my career I got break after break after break. And then I was broke. (Colin Farrell)

Half the marriages in Hollywood are like tennis. Love means nothing. (Jerry Colonna)

Would I consider re-marriage? Yes, if I could find a man who had $15 million, who would sign over half of it to me … and guarantee he'd be dead within the year. (Bette Davis)

Face it: love isn't like the movies. Walt Disney and Doris Day lied to us. I want my money back. (Jane Mitchell)

Some communist – she travels by Rolls Royce. (Robert Duvall on Vanessa Redgrave)

If you woke up in a motel with a dead whore who'd been stabbed, who would you call? Sam Spiegel. (Billy Wilder)

How could he do this to me after all my work to build him up into a star? (Jack Warner after hearing James Dean had died).

Before Tom Hanks made *Big*, he wasn't even a household name in his own household. (Barry Norman)

The British film industry is alive and well and living in Los Angeles. (Michael Caine)

When I worked with Bette Davis I was never so scared in my life. And I was in the war. (John Mills)

If you don't have a psychiatrist in Hollywood, people think you're crazy. (Patrick Bergin)

If Robert De Niro gains weight for a role it's called 'artistic dedication'. If I do it's called 'letting yourself go'. (Brenda Fricker)

Zsa Zsa Gabor has discovered the secret of perpetual middle age. (John Huston)

Douglas was so impressed with the script, he asked if Mr Homer had written any other ones. (Russian radio station deejay on Kirk Douglas after he had signed for *Ulysses*)

Joan Crawford is like that old joke about Philadelphia. First prize, four years with her; second prize, *eight*. (Franchot Tone)

I'm not really Henry Fonda. Nobody could have that much integrity. (Henry Fonda)

He moves with all the athletic grace of a constipated warthog in clogs. (Simon Crook on Anthony Hopkins in *Bad Company*)

George Sanders had a face which, even in his twenties, looked as though he had rented it on a long lease and had lived in it for so long he didn't want to move out. (David Niven)

When I first went into the movies Lionel Barrymore played my grandfather. Later he played my father and finally he played my husband. If he'd lived longer I'm sure he would have been my son. Only women age in Hollywood. Men age downwards. (Lillian Gish)

It's not the time it takes to take the take that takes the time. It's the time it takes between the takes that takes the time. (Steven Spielberg)

Victoria Principal married a plastic surgeon. Isn't that convenient? (Joan Rivers)

That son of a bitch is acting even when he takes his pyjamas off. (Carole Lombard of her husband William Powell)

By and large I feel that most actors are like overgrown schoolboys playing at being men. (Diana Dors)

There are no real men in Hollywood. They're either married, divorced… or want to do your hair. (Doris Day)

Tallulah Bankhead is always skating on thin ice … and everyone wants to be there when it breaks. (Beatrice Campbell)

I used to work for a living; then I became an actor. (Roger Moore)

On Rex Harrison's seventieth birthday I suggest we hire a telephone box and invite all his friends to a party. (Doug Hayward)

She's a born proselytiser. I sometimes think that any position you take up she'll make you change your mind even if she holds an opposite view. (Michael Redgrave on his daughter Vanessa)

Paul Newman is an oddity in the film business. He loves his wife. (Gore Vidal)

To say that Michael Winner is his own worst enemy is to evoke a ragged chorus from odd corners of the film industry of 'Not while I'm alive'. It amuses him to confront the world in the guise of a self-made shit. (Barry Norman)

If I had cast Ronald Reagan as the presidential candidate in 'The Best Man' it would have sated his appetite for the presidency and we'd all have been much better off. (Gore Vidal)

Liz Taylor's getting married again. By now she must regret she didn't buy a time-share in Niagara Falls. (Johnny Carson)

Show business is worst than dog eat dog. It's 'dog won't return other dog's phone calls'. (Woody Allen)

Actors marrying actors play a dangerous game. They're always fighting over the mirror. (Burt Reynolds)

Not to upset people in my films would be an obscenity. (Roman Polanski)

All my life I've told my lovers, 'Don't wake me up during the night unless you want to make love'. You'd be surprised how few times I've been awakened. (Hedy Lamarr)

Madonna and Sean Penn were the beauty and the beast. But which was which? (Joan Rivers)

MEN AND WOMEN

Cosmetic surgery in the U.S. is way, way ahead of every other branch of medicine. If you don't believe me, just look at Goldie Hawn. She's 107. (Rich Hall)

Girls have an unfair advantage over men. If they can't get what they want by being smart, they can get it by being dumb. (Yul Brynner)

Within two years women will be able to get breast enhancement done in their lunch hour. You get turned down for a raise in the morning. In the afternoon you can go in and try again. (Jay Leno)

More women believe in ghosts than men. They've had experience. They have sex with a guy, they turn around, he's vanished. (Jay Leno)

Glamour is that indefinable something about a girl with massive tits. (Mort Sahl)

The only nice women are the ones who have had no opportunities. (Frederick Lonsdale)

The girls are so beautiful here. It's sad to think that twenty years from now they'll all be five years older. (Will Rogers)

Women are sometimes adequate substitutes for masturbation, but it takes a lot of imagination. (Karl Kraus)

Phyllis Diller's has so many facelifts, there's nothing left in her shoes. (Bob Hope)

You date a girl for two years and then the nagging starts: 'I want to know your name'. (Mike Binder)

Shakespeare wrote of the Seven Ages of Man but he didn't write of the Seven Ages of Woman. He couldn't find an age that any woman would admit to. (F.J. Mills)

Women are divided into those who think they're always right. (Danny De Vito)

A woman's best love letters are always written to the man she's betraying. (Lawrence Durrell)

Marilyn Monroe, for me, was like smoking. I knew she was bad for my health but I couldn't give her up. (Billy Wilder)

The one thing I couldn't forgive my girlfriend for is if she found me in bed with another woman. (Steve Martin)

If there hadn't been women, we'd still be squatting in caves eating raw meat. We made civilisation to impress our girlfriends. (Orson Welles)

My sex life is now reduced to fan letters from an elderly lesbian who wants to borrow $800. (Groucho Marx in 1974)

I still chase women – but only when they're running downhill. (Bob Hope)

A woman's strategy consists in being very good at first in order to capture a man's confidence, then pulling in the reins and finally grasping them so firmly that he has to dance according to her desires. (Adolf Hitler)

A woman must be a nice cuddly little thing: soft, sweet and stupid. (Adolf Hitler)

There's a great woman behind every idiot. (John Lennon)

It's because I never smoked, drank or touched a girl – until I was eleven years old. (George Moore on the reasons for his longevity)

I went out with a girl who said, 'Don't treat me like a date. Treat me like you would your mom.' So I didn't call her for six months. (Zorba Jevon)

Throughout my life I've been consumed with taking anything that was available, be it chocolate, a piece of cake, potato chips or girls. My wife knew of my infidelities but stayed with me. Funnily enough, it was only when I stopped all that and was faithful that she left me. There's a moral there somewhere but I can't be bothered to work it out. (Michael Winner)

I was too trusting of women in the past and I got badly burned. I've told my sons I won't let 'em date till they're 45. (Sylvester Stallone)

If a woman tells you she's 20 and looks 16, she's 12. If she tells you she's 26 and looks 26, she's damn near 40. (Chris Rock)

You don't take a sausage roll to a banquet. (Winston Churchill on why he didn't take his wife with him to an official function in Paris)

Q. What's the difference between a woman from Wigan and a walrus?
A. One's got a moustache and smells of fish and the other lives in the sea. (Internet joke)

Irish women like the simple things in life – like Irish men. (Mary Coughlan)

Dorothy Parker said 'Men seldom make passes at girls who wear glasses.' Bollocks. Men would make passes at badgers who wore glasses if they thought they were going to get a shag. (Jo Brand)

FOOD AND WEIGHT

My idea of perfection is a man who turns into a pizza after sex. (Deirdre Walsh)

I've got such a big belly, my sister told me if it was on my girlfriend she'd be six months gone. I replied, 'It was and she is!' (Benny Hill)

Nouvelle cuisine, roughly translated, means 'I can't believe I just spent 96 dollars and I'm still hungry.' (Mike Kahn)

I went on a diet, but I had to go on another one at the same time because the first diet wasn't giving me enough food. (Barry Martin)

I joined a health club last year which cost me a fortune but I still didn't lose any weight. Apparently you have to turn up. (Hal Roach)

I've learned not to put things in my mouth that are bad for me. (Monica Lewinsky on Larry King's chatshow)

A restaurant is the only place in the world where people are happy to be fed up. (Hal Roach)

Bill Clinton's foreign policy experience stemmed mainly from having had breakfast at the International House of Pancakes. (Pat Buchanan)

No diet will remove all the fat from your body because the brain is entirely fat. Without a brain you might look good,

but all you could do is run for public office. (George Bernard Shaw)

I make a lot of jokes about vegetarians in my act but most of them don't have the strength to protest. (Ardal O'Hanlon)

The only exercise I get is walking behind the coffins of my fit friends. (Peter O'Toole)

By six years of age I ate so much I had stretch marks around my mouth. (Joan Rivers)

Whenever I watch TV and see those poor starving kids all over the world, I can't help but cry. I mean I'd love to be skinny like that, but not with all those flies and death and stuff. (Mariah Carey)

Don't wreck a sublime chocolate experience by feeling guilty. Chocolate isn't like premarital sex. It will not make you pregnant. (Lara Brody)

I do the Peter Fonda work-out, not the Jane one. In other words I wake up, take a hit of acid, smoke a joint and then run round to my sister's house looking for money. (Kevin Meaney)

Whenever I go to a restaurant, I always ask for a table near the waiter. (Orson Welles)

The average airplane is 16 years old, and so is the average airplane meal. (Joan Rivers)

I have to go now, Clarice. I'm having an old friend for dinner. (Anthony Hopkins as Hannibal the Cannibal in *The Silence of the Lambs*.)

Ask not what you can do for your country, but what's for lunch. (Orson Welles)

I haven't trusted polls since I read that 62% of women had affairs during their lunch hour. I've never met a woman in my life who would give up lunch for sex. (Erma Bombeck)

Anyone who uses the phrase 'As easy as taking candy from a baby' has never taken candy from a baby. (Roger Howe)

I told my doctor I get very tired when I go on a diet so he gave me pep pills. The result? I just ate faster. (Joe E. Lewis)

The food in that restaurant is just terrible. And such small portions. (Woody Allen)

If you want to find out some things about yourself in vivid detail, try calling your wife fat. (P.J. O'Rourke)

What's really bad is going up to a friend you haven't seen in a while and saying 'Oh my God, you're pregnant!' and they're not. I've done that, and I'll tell you – the look on his face! (Ellen DeGeneres)

Apparently eight out of ten women prefer making love to a fat man. I don't know his name but he's having a bloody good time. (Andy Hamilton)

My wife is on a diet of coconuts and bananas. She hasn't lost any weight, but boy can she climb a tree! (Henny Youngman)

Jackie Gleason once donated a sweater to a charity. There are now four refugees living in it. (Bob Hope)

I've decided that perhaps I'm bulimic but just keep forgetting to purge. (Paula Poundstone)

The maitre d' goes over to the middle-aged Jewish couple dining in his restaurant and says 'Is anything all right?' (Fred Metcalf)

A gourmet who thinks of calories is like a tart who looks at her watch. (James Beard)

I went into a McDonalds restaurant yesterday and ordered some fries. The girl at the counter said, 'Would you like some fries with that?' (Jay Leno)

SEX

It's a bad thing because it rumples the bedclothes. (Jacqueline Kennedy Onassis)

We're living in an age where it's the men who say, 'Not tonight darling, I have a headache.' **(Oprah Winfrey)**

A man can sleep around, no questions asked, but if a woman makes 19 or 20 mistakes she's a tramp. (Joan Rivers)

My mother said this: 'Sex is a dirty, disgusting thing you save for somebody you love.' (Carol Henry)

Robert Benchley and I had an office so tiny that an inch smaller and it would have been adultery. **(Dorothy Parker)**

My Aunt Lorraine said, 'Bob, you're gay. Are you seeing a psychiatrist?' 'No,' I said, 'I'm seeing a lieutenant in the navy.' (Bob Smith)

Remember when safe sex meant doing it when your parents were out of town? (Karen Renaud)

Vasectomy means never having to say you're sorry. **(Anon)**

Being good in bed means I'm propped up with pillows and my mom brings me soup. (Brooke Shields)

Women have to love before they have sex; men have to have sex before they can love. (Rhona Henderson)

I feel like a million tonight – but one at a time. (Mae West)

Older women are best because they always think they may he doing it for the last time! (Ian Fleming)

Many years ago my brother gave me some advice about women. There are three rules, he said. One, they all want it. Two, no means yes. Three, never ever mention sex. (James Healy)

Why should we take advice on sex from The Pope? If he knows anything about it, he shouldn't. (George Bernard Shaw)

Anyone might become homosexual after seeing Glenda Jackson nude. (Auberon Waugh)

Whoever called it necking was a poor judge of anatomy. (Groucho Marx)

A U.S. survey on sexual behaviour has found that most American men think about sex an average of ten times an hour – unless they happen to be called Bill Clinton, in which case they actually *have* sex an average of ten times and hour. (Olaf Tyaransen)

A promiscuous person is someone who's getting more sex than you are. (Victor Lownes)

Rape is assault with a friendly weapon. (Marion Brando)

Did you hear about the man who mixed up his Viagra with his constipation pills? He didn't know if he was coming or going. (Ted Fitzpatrick)

I have to stop taking Viagra because I can't zip up my trousers. (Richard Harris)

I once asked a girl for oral sex. She thought that meant just talking about it. (Frank Carson)

I believe sex is one of the most beautiful and wholesome things that money can buy. (Steve Martin)

I don't understand the Mile High Club. How can you fit two people into an airplane bathroom to have sex? I barely have room to have sex in there by myself. (Ellen DeGeneres)

You remember climbing your first mountain in much the same way you remember your first sexual experience, except that walking doesn't make as much mess, and you don't cry for a week if Ben Nevis forgets to phone next morning. (Muriel Gray)

The main problem with men is that God gave us a brain and a penis, but only enough blood to run one of them at a time. (Robin Williams)

Gigolos live by the sweat of their fraus. (Chris Furlong)

They're always talking about 'what separates the men from the boys'. I'll tell you what separates the men from the boys. The sodomy laws. (George Carlin)

A survey was done on the nocturnal habits of men. The results showed that 5% got up to drink a glass of water, 10% got up to go to the bathroom, and 85% got up to go home. (Joe Uris)

Scientists have discovered a food that reduces a woman's sex drive by 99%. Wedding cake. (Jim Davidson)

I took my wife to a wife-swapping party. I had to throw in some cash. (Henny Youngman)

My God, when I discovered sex for the first time – the guilt, the remorse, the embarrassment, the shame. And that was just masturbation. (Woody Allen)

The only reason my wife has an orgasm is so she'll have something else to moan about. (Bob Monkhouse)

It must be wonderful to be a doctor. In what other job could you ask a girl to take her clothes off, look her over at your leisure and then send the bill to her husband? (Marty Allen)

I knew it was time to stop cheating when I was with my girlfriend and I found myself fantasising about my wife. (Mick Jagger)

The most unsatisfactory men are those who pride themselves on their virility, and regard sex as if it were some form of athletics in which you win cups. (Marilyn Monroe)

A hooker told me she'd do anything for $50. 'Paint my house,' I said. (Henny Youngman)

CLOTHING

I was standing at the bus stop the other day when a man came up to me and said, 'Have you got a light, mac?' I said, 'No, I've got a dark brown overcoat.' (Chic Murray)

A husband said to his wife, 'I don't know why you wear a bra, you've got nothing to put in it.' She replied, 'You wear briefs, don't you?' (Dawn French)

Scientists say a woman listens with her whole brain, whereas a man only does so with half of it. The other half is picturing her naked. (Jay Leno)

The definition of a yuppie is a man who has different gardening clothes for his front and back garden. (Des McCarthy)

I won't say her bathing suit was skimpy, but I've seen more cotton in the top of an aspirin bottle. (Henny Youngman)

By the time a man is successful enough to buy his wife dresses to fit her figure perfectly, she no longer has one. (Henny Youngman)

I didn't recognise you with your clothes on. (Groucho Marx)

A dead atheist is someone who's all dressed up with nowhere to go. (James (Durcan)

The best thing about masturbation is that you don't have to dress up for it. (Truman Capote)

The two most rented things in the world are a rented woman and a rented tuxedo. (P.J. O'Rourke)

It could have been spinach dip. (Monica Lewinsky on the infamous stain Bill Clinton left on her dress)

Victoria Beckham gives away all her old clothes to starving children. Who else are they going to fit? (Pauline Calf)

Losing one's glove is sorrow enough, but nothing compared with the pain of losing one's glove, discarding the other, then finding the first one again. (Piet Hein)

Why did 'Sir' Robin Day's daddy never tell him you don't wear a spotted bow-tie with a top hat and morning coat unless you want to look a bloody fool. The Queen must have thought he was some sort of lion tamer from the circus when he turned up to collect his knighthood. (Auberon Waugh)

Brides today are wearing their dresses shorter. And more often. (Milton Berle)

Women are funny. Last Christmas my wife gave me two neckties. I got up on Christmas morning, put one of them on, went downstairs, showed it to her, and the first thing she said was, 'And just what was wrong with the other one?' (Dave Allen)

In my day, hot pants were things we had, not wore. (Bette Davis)

In England if you're a duchess you don't need to be well-dressed. It would be thought quite eccentric. (Nancy Mitford)

Men like me because I don't wear a brassiere. (Jean Harlow)

A beautiful girl went to see an artist. 'Can you paint me in the nude?' she asked. 'Certainly,' he replied, 'But I'll have to keep my socks on. I have to have somewhere to put the brushes.' (Frank Muir)

SPORT

At 39, Ali floats like an anchor and stings like a moth. (Ray Gandolf)

90% of my money went on women, fast cars and booze. The rest I wasted. (George Best)

I'd rather play in front of a full stadium than an empty crowd. (Johnny Giles)

The Baggio brothers, of course, aren't related. (George Hamilton)

He kicked wide of the goal with great precision. (Des Lynam)

Everything in our favour was against us. (Danny Blanchflower)

You know what I love best about baseball? The pine tar, the resin, the grass, the dirt – and that's just in the hot dogs. (David Letterman)

The Brazilians aren't as good as they used to be, or as they are now. (Kenny Dalglish)

I have nothing to say. Any questions? (Hockey player Phil Watson at a press conference)

The main difference between being in a relationship and prison is that in prison they let you play softball at the weekends. (Bobby Kelton)

If we get promotion, let's sit down and see where we stand. (Roy McFarland)

When I said 'You're a disgrace to mankind' I was talking to myself, not you. (John McEnroe to Wimbledon umpire in 1981)

I was in a no-win situation so I'm glad I won rather than lost. (Frank Bruno)

It was a match that could have gone either way and very nearly did. (Jim Sherwin)

The only winter sport at which the British excel is phoning in sick. (Ronald White)

What you've got to remember about Michael Schumacher is that under that cold professional Germanic exterior beats a heart of stone. (Damon Hill)

Williams beat Shilton from 35 yards. And you don't beat Shilton from 35 yards. (Peter Jones)

Ski-ing is the only sport where you can spend an arm and a leg to break an arm and a leg. (Henry Beard)

Martin O'Neill, standing, hands on hips, stroking his chin. (Mike Ingram)

The only thing you need to know about Wimbledon is that English players always get knocked out in the first round. In that sense they're quite like English boxers. (Joe O'Connor)

Half of them were booing and half of them were cheering. The only problem was that the half that were cheering were cheering the half that were booing. (Craig Brown when he was managing Clyde in 1996)

The fact that Joe DiMaggio's marriage to Marilyn Monroe broke up proves that it's difficult for the same man to be an expert at America's two favourite pastimes. (Joe E. Brown)

He floats like a butterfly and tackles like one too. (Brian Clough on Trevor Francis)

We didn't under-estimate them. They were just a lot better than we thought. (Bobby Robson after England played Cameroon in the 1990 World Cup Finals)

He's so fat, his bathtub has stretch marks. (Pat Williams on basketball player Charles Barkley)

We were happily married for eight months. Unfortunately, we were married for 4½ years. (Nick Faldo)

He uses running side, reverse side, back side, any sort of side. The only side he hasn't attempted is suicide. (Ray Reardon on Alex Higgins. Actually Higgins did attempt the latter as well, according to his autobiography)

The trouble with you, son, is that your brains are all in your head. (Bill Shankly to one of his players who underwhelmed him).

There's nothing wrong with the car except that it's on fire. (Murray Walker)

When I lost my world decathlon record I took it like a man: I only cried for 10 hours. (Daley Thompson)

A player as talented as David Beckham comes with a lot of baggage – most of it Louis Vuitton. (Joe O'Connor)

It's a conflict of parallels. (Alex Ferguson)

A Kerry footballer with an inferiority complex is one who thinks he's just as good as everyone else. (John B. Keane)

I saw George Foreman shadowboxing, and the shadow won. (Muhammad Ali)

Jack Charlton's philosophy of soccer was, 'If plan A fails, try Plan A.' (Mark Lawrenson)

I love football. I just don't like it. (John Maughan)

The last time we played England we beat them one–all. (Jim Sheridan in 1994)

There was no point in him coming to team talks. All I used to say was, 'Whenever possible, pass the ball to George.' (Sir Matt Busby on George Best)

The secret of being a good manager is to keep the six players who hate you away from the five who are undecided. (Jock Stein)

If you don't believe you can win, there's no point in getting out of bed at the end of the day. (Neville Southall)

MARRIAGE

I saw six men punching and kicking the mother-in-law. My neighbour said, 'Are you not going to help?' I said, 'No, six should be enough.' (Les Dawson)

When Woodrow Wilson proposed to me. I was so surprised I nearly fell out of the bed. (Edith Bolting)

My best friend ran away with my wife, and let me tell you – I miss him. (Henny Youngman)

In the first year of marriage he talks and she listens. In the second year she talks and he listens. The third year, they both talk and the neighbours listen. (Donald McGill)

Zsa Zsa Gabor is an excellent housekeeper. Every time she gets divorced, she keeps the house. (Henny Youngman)

I spent so much on my girlfriend I decided to marry her for my money. (Richard Pryor)

Down with marriage – be a bachelor like your father was! (Spike Milligan)

You have only to mumble a few words in church to get married, and a few words in your sleep to get divorced. (Hal Roach)

Judging by the divorce rate, a lot of people who say 'I do', don't. (Hal Roach)

Mixed emotion is watching your mother-in-law drive over a cliff in your new Ferrari. (Long John Lebel)

My mother-in-law broke up my marriage. One day my wife came home early and found us in bed together. (Lenny Bruce)

I knew Elizabeth Taylor when she didn't know where her next husband was coming from. (Johnny Carson)

I've been in love with the same woman for 41 years. If my wife finds out, she'll kill me. (Henny Youngman)

When you marry a mistress, you create a job opportunity. (James Goldsmith)

My wife said I never listen to her. At least that's what I *think* she said. (Milton Berle)

The trouble with my wife is that she's a whore in the kitchen and a cook in bed. (Geoffrey Gorer)

Marriage interferes with romance. Anytime you have a romance, your wife is bound to interfere. (Groucho Marx)

It was a Scottish wedding – the confetti was on elastic. (Bob Monkhouse)

My wife doesn't care what I do when I'm away from home as long as I don't have a good time. (Lee Trevino)

I bequeath all my property to my wife on the condition that she remarry immediately. Then there will be at least one man to regret my death. (Heinrich Heine)

I got a lovely dog for my wife. It was a great swap. (Bob Monkhouse)

Few things in life are more embarrassing than having to inform an old friend you've just become engaged to his fiancée. (W.C. Fields)

I've always been different. Now that people are living together, I want to get married. (Brigitte Bardot)

An old man marrying a young girl is like buying a book for someone else to read. (H. W. Thompson)

Why does a woman work 10 years to change a man's habits and then complain that he's not the man she married? (Barbra Streisand)

Congratulations are in order for Woody Allen. He and Soon Yi have a brand new baby daughter. It's all part of Woody's plan to grow his own wives. (David Letterman)

My husband asked me if I'd still love him if he was poor. I said I would, but I'd miss him terribly. (Zsa Zsa Gabor)

PLAYING WITH SAYINGS

Never have children, only grandchildren. (Gore Vidal)

Man is a creature made at the end of a week, when God was tired. (Mark Twain)

I like to wake up every morning feeling a new man. (Jean Harlow)

Never eat on an empty stomach. (Dawn French)

Only the young die good. (Oliver Herford)

An apology is the only thing that will enable you to have the last word with a woman. (Peter Cagney)

If you want to dress to please your husband, wear last year's clothes. (Joey Bishop)

Since we have to speak well of the dead, let's knock 'em while they're alive. (John Sloan)

In spite of the cost of living, it's still very popular. (Anon)

The greatest undeveloped territories in the world are usually between people's ears. (Samuel Herbert)

Reincarnation is making a comeback. (Graffiti)

Don't become a clairvoyant: there's no future in it. (Jackie Mason)

The best-laid plans of mice and men end up on the cutting room floor. (P.G. Wodehouse)

Absence makes the heart go wander. (Bill Kelly)

I am therefore I think. (Woody Allen)

Many wise words are spoken in jest, but many more stupid ones said in earnest. (Jack Farrelly)

The trouble with mixing business and pleasure is that pleasure usually gets priority. (Dave Allen)

Experience is a good teacher, but she sends in terrific bills. (Minna Antrim)

A fool and his money get invited to all the best parties. (Anon)

In God we trust. All others must pay. (Sign over bar counter)

There's no time like the present for postponing what you don't want to do. (Quentin Crisp)

Sado-masochism means never having to say you're sorry. (Graffiti)

An open marriage is nature's way of telling you you need a divorce. (Graffiti)

Some men are born mediocre, some achieve mediocrity and some have mediocrity thrust upon them. (Joseph Heller)

Somewhere on the earth every ten seconds a woman gives birth to a child. We must find this woman and stop her at once. (Sam Levinson)

When everybody is somebody, nobody is anybody. (Hilaire Belloc)

The great BBC maxim is: if it ain't broke, break it. (Terry Wogan)

Go on failing. Only next time, try to fail better. (Samuel Beckett)

There's less to life than meets the eye. (Woody Allen)

At my age travel broadens the behind. (Stephen Fry)

In spring a young man's fancy turns to thoughts of love – and also in summer, autumn and winter. (James Simpson)

Anyone who sleeps like a baby hasn't got one. (James Simpson)

Money can't buy you friends; just a better class of enemy. (Spike Milligan)

Time and tide wait for no man, but time always stands still for a woman of thirty. (Robert Frost)

A friend that isn't in need is a friend indeed. (Kin Hubbard)

When I was young I thought money was the most important thing in life. Now that I'm old I know it. (Oscar Wilde)

Greater love than this no man hath, than that he lay down his friends for his life. (Jeremy Thorpe)

No man is old enough to know better. (Holbrook Jackson)

Love your enemy. It will drive him nuts. (Eleanor Doan)

If you can keep your head when all about are losing theirs, you'll be taller than everybody else. (Kenny Everett)

Everything that can go wrong, will go wrong. And everything that can't possibly go wrong will also go wrong. (Bob Monkhouse)

If at first you don't succeed, your skydiving days are over. (Milton Berle)

ANIMALS

If vegetarians only eat vegetables, does that mean humanitarians only eat people? (Jasper Carrott)

I don't trust camels, or any other animal that can go without drink for a week. (Brendan Behan)

A man is like a cat: chase him and he'll run, sit still and ignore him and he'll come purring at your feet. (Helen Rowland)

My wife does bird imitations. She watches me like a hawk. (Hal Roach)

I once bought a pig into my house. I was worried about the smell but it didn't prove to be a problem. After a while he got used to it. (Quentin Crisp)

You were allowed to kiss the horse in cowboy films when I was young, but not the woman. (Clark Gable)

The great thing about racehorses is that you don't need to take them for walks. (Albert Finney)

A tenant complained to a landlord about the profusion of mice in his flat. 'There isn't a single mouse in that flat,' the landlord protested. 'I know,' said the tenant, 'they're all married with large families.' (Jimmy O'Dea)

John McEnroe is as charming as a dead mouse in a loaf of bread. (Clive James)

There are three reasons for breastfeeding. The milk is always at the right temperature, it comes in attractive containers, and the cat can't get it. (Irene Chalmers)

I'd sooner share a phone booth with a cobra than marry Marlene Dietrich. (Josef von Sternberg)

Louis B. Mayer has the memory and hide of an elephant. The only difference is that elephants are vegetarians, and his diet is his fellow man. (Herman Mankiewicz)

I've often wondered if sheep count people when they're trying to get to sleep. (Sid Caesar)

I never married because there was no need. I have three pets at home which answer the same purpose as a husband. I have a dog which growls every morning, a parrot which swears all afternoon, and a cat that comes home late at night. (Marie Corelli)

I get tired of films. When you remember that one of the most popular stars of all time was Lassie, a dog, it kind of puts it in perspective. (Robert Mitchum)

My cat can talk. I asked her what two minus two was and she said nothing. (Leopold Fechtner)

A cat isn't fussy, just as long as you remember he likes his milk in the shallow rose-patterned saucer and his fish on the blue plate, from which he will take it and eat it off the floor. (Arthur Bridges)

My dog is half Labrador, half pit bull. She bites off my leg and then brings it back to me. (Frank Carson)

Did you know that humans eat more sharks than sharks eat humans? (David Attenborough)

If you send your dog to fetch the paper, make sure it knows which one to get. And don't give it too much money or it might not come back. (Mike Harding)

I lost my dog so I put an ad in the paper. I wasn't sure how to word it so I just put 'Here, boy!' (Frank Carson)

The last time a mosquito bit me it had to sign itself into the Betty Ford Clinic for detox. (Richard Harris)

My dog is worried about the fact that his food has gone up by £1 a can. That's £7 in dog money. (Milton Berle)

My father took up bird-watching. He's very serious about it. He bought binoculars. And a bird. (Rita Rudner)

I love the way cats stare at me. It's this long, penetrating glare that suggests they have some dirt on me: 'I know you steal from work I've seen the pens with the company name on them. Here are my demands. Fancy Feast only, no store brands or I'm on the phone to management.' (Andi Rhoads)

I have eyes like a bullfrog, a neck like an ostrich and long, limp hair. You just have to be good to survive with that kind of equipment. (Bette Davis)

Appeasers are people who believe that if you keep throwing steaks at a tiger, he'll become a vegetarian. (Heywood Broun)

If the crow could feed in quiet, he would have more meat. (Horace)

The male is a domestic animal which, if treated with firmness and kindness, can be trained to do most things. (Jilly Cooper)

My mom took me to a dog show ... and I won. (Rodney Dangerfield)

The cats clung to him as though he owed them money. (Anthony Armstrong)

It's untrue that my dog can talk. If he says he can, he's a bloomin' liar. (Jack Fennell)

The easiest hunt is the one to find a scapegoat. (Benjamin Franklin)

And now here are the results of the Sheepdog Trials. All the sheepdogs were found not guilty. (Keith Waterhouse)

I envy the kangaroo. His pouch set-up is extraordinary. The baby crawls out of the womb when it's about two inches long, gets into the pouch and proceeds to mature. I'd have a baby if it would develop in my handbag. (Rita Rudner)

Fame is a bit like being pecked to death by a thousand pigeons. (Bob Hoskins)

Dogs aren't that bright. Everytime you come home they think it's amazing. You walk in the door and the joy of it almost kills him. 'It's that guy again! How does he do it!' (Jerry Seinfeld)

Garfield's Law states that cats instinctively know the precise moment when their owners will awaken. They then awaken them ten minutes sooner. (Jim Davis)

A horse show is a lot of horses showing their asses to a lot of horses asses showing their horses. (Denis Leary)

The Safari Park had a notice that said, 'Elephants: Please Stay In Your Car'. (Spike Milligan)

Customer in pet shop: Have you any dogs going cheap?
Owner: No, all our dogs go 'Woof'.
(Nigel Rees)

An elephant is a mouse drawn to government specifications. (John D. Sheridan)

Sign in a vet's office: 'Back In Ten Minutes. Sit!' (Joe McNamara)

Women who can't bear to be separated from their pet dogs often send their children to boarding schools quite cheerfully. (George Bernard Shaw)

When a man wants to murder a tiger he calls it sport. When a tiger wants to murder him, he calls it ferocity. (George Bernard Shaw)

You can't train cats. They're too smart to do tricks! (Sasha Sullivan)

Shortly after the pregnant snake swallowed the rubber ball, she gave birth to a bouncing baby boa. (John Crosbie)

I am fond of pigs. Dogs look up to us. Cats look down on us. Pigs treat us as equals. (Winston Churchill)

Some of my best leading men have been dogs and horses. (Elizabeth Taylor)

Do bees hum because they don't know the words? (Sue Pollard)

Dogs are preferable to wives. The licence is cheaper, and they already have fur coats. (Bob Monkhouse)

My dog's been eating garlic. His bark is worse than his bite. (Jasper Carrott)

How is it that when the doorbell rings, the dog always thinks it's for him? (Noel V. Ginnity)

LITERATURE

I have three daughters. As a result I played King Lear almost without rehearsal. (Peter Ustinov)

Tom Wolfe was a one book boy with the brains and guts of three mice. (Ernest Hemingway)

When you re-read Faulkner you're conscious all the time how he fooled you the first time. (Ernest Hemingway)

I'm the only 'principal' he ever had. (Jeffrey Archer's old headmaster)

That sonofabitch writes on water. (Ben Hecht on Ernest Hemingway)

Where were you fellows when the page was blank? (Fred Allen to a group of critics)

I wish he'd blotted out a thousand. (Ben Jonson on Shakespeare, apropos The Bard's boast that he'd never blotted out a word he wrote).

Finnegans Wake is one long spelling mistake. (Ernest Cox)

Ted Hughes has been more pissed on than the back wall of the Batley Working Men's Club before a Dusty Springfield concert. (Alan Bennett)

They sent Oscar Wilde to prison for doing what writers today get knighted for. (Wilfrid Hyde-White)

I remember coming across George Bernard Shaw at the Grand Canyon and finding him refusing to admire it. He was jealous! (J.B. Priestley)

Wordsworth was a half-witted sheep who bleated articulate monotony. (James Stephens)

The greatest mind ever to stay in prep school. (Norman Mailer on J.D. Salinger)

They were a couple you wouldn't invite home to your mother, even if you were certain that she was out. (Con Houlihan on Dylan Thomas and his wife Caitlin)

Unless the bastards have the courage to give you unqualified praise, I say ignore them. (John Steinbeck on critics)

Thomas Gray walks as if he had fouled his clothes – and looks as if he smelt it. (Christopher Smart)

Whenever a friend succeeds, a little something in me dies. (Gore Vidal)

Raymond Chandler is in danger of becoming a talented hack. (*Time* magazine)

I saw *Under Milk Wood* on TV and I thought the best thing in the programme was the 20 minute breakdown. (George Murray)

She looked like Lady Chatterley above the waist and the gamekeeper below. (Cyril Connolly on Vita Sackville-West)

I turned *Hamlet* down because it was going to take up too much of my drinking time. (Richard Harris)

There's a very big difference between novels and poetry. You starve with one of them. (Dermot Bolger)

His brain is a half-inch layer of champagne poured over a bucket of Methodist near-beer. (Benjamin de Casseres on George Bernard Shaw)

Robert Louis Stevenson imagined no human soul, and invented no story that anyone will ever remember. (George Moore)

With the single exception of Homer, there is no eminent writer, not even Sir Walter Scott, whom I despise so entirely as I despise Shakespeare when I measure my mind against his. It would positively be a relief to dig him up and throw stones at him! (George Bernard Shaw)

I hate to think of this sort of book getting into the wrong hands. As soon as I've finished it, I shall recommend they ban it. (Tony Hancock on a pornographic novel he was reading)

I've been brooding in my bath, and it is my considered opinion that the success of *Waiting for Godot* is the end of the theatre as we know it. (Robert Morley).

Evelyn Waugh looked like a letter delivered to the wrong address. (Malcolm Muggeridge)

A clever, talented, admirably executed fake. (Gore Vidal on *The Naked and the Dead*)

There are three rules for writing novels. Unfortunately, nobody knows what they are. (Somerset Maugham)

Brief Encounter strained credibility to the extreme. The notion that a marriage could withstand such temptation – and, more importantly, that the trains would run on time. (Desmond Bond)

I can rarely tell whether his characters are making love or playing tennis. (Joseph Kraft on William Faulkner)

One of the surest signs of his genius is that women detest his books. (George Orwell on Joseph Conrad)

I can't remember a single interesting remark Faulkner ever made. (Norman Mailer)

I think you judge Truman Capote a bit too charitably when you call him a child. He's more like a sweetly vicious old lady. (Tennessee Williams)

Heinrich Heine so loosened the corsets of the German language that today every little salesman can fondle her breasts. (Karl Kraus)

To me, Poe's prose is unreadable – like Jane Austen's. No, there's a difference: I would read his prose on a salary, but not Jane's. (Mark Twain)

I am fairly unrepentant about Edith Sitwell's poetry. I really think that three-quarters of it is gibberish. However, I must crush down these thoughts or the dove of peace will hit on me. (Noel Coward)

Romeo and Juliet spent one night together and the next day he committed suicide. Then she committed suicide. I'm trying to find out what went on in that bedroom. (Alan King)

The humour of Dostoevsky is the humour of a bar-loafer who ties a kettle to a dog's tail. (W. Somerset Maugham)

Oscar Wilde festooned the dung heap on which he had placed himself with sonnets just as people grow honeysuckle around outdoor privies. (Quentin Crisp)

About agents: I deal direct because I will not give 10% to any son of a bitch to do what I can do better. (Ernest Hemingway)

Euripides was a cliché anthologist and maker of ragamuffin manikins. (Aristophanes)

Is there no beginning to your talents? (Clive Anderson to Jeffrey Archer in 1991)

James Joyce was an essentially private man who wished his total indifference to public notice to be universally recognised. (Tom Stoppard)

If a playwright is funny, the English look for the serious message, and if he is serious they look for the joke. (Sacha Guitry)

The reason James Joyce is inaudible is because he spends most of his time talking to himself. (G.K. Chesterton)

Very nice, but there are dull stretches. (Comte de Rivarol on a two-line poem)

Albert Camus won the Nobel Prize for his novel *The Outsider*, which says, in effect, that life is meaningless. The novel's dust jacket reported that Camus died in a car wreck in 1960. It should have added, 'Not that it matters'. (Dexter Madison)

Monica Baldwin's book *I Leap Over the Wall* was very interesting. I must say it has strengthened my decision not to become a nun. (Noel Coward)

Waldo Emerson is one of those people who would be enormously improved by death. (Saki)

She's so boring you fall asleep half way through her name. (Alan Bennett on Arianna Stassinopoulos)

He spent his time looking for the *mot juste* – and then killing it off. (Ford Madox Ford on Joseph Conrad)

Andre Gide was just a big old French queen with a rough face. (Truman Capote)

He grew up from manhood into boyhood. (R.A. Knox on G.K. Chesterton)

He had double chins all the way down to his stomach. (Mark Twain on Oliver Wendell Holmes)

The more I read him, the less I wonder why they poisoned him. (Thomas Babington Macaulay on Socrates)

Hemingway was always willing to lend a helping hand to the one above him on the ladder. (F. Scott Fitzgerald)

We've all heard that a million monkeys banging on a million typewriters will eventually reproduce the entire works of Shakespeare. Now, thanks to the internet, we know that this is not true. (Robert Wilensky)

To say Agatha Christie's characters are cardboard cut-outs is an insult to cardboard. (Ruth Rendell)

A woman whose face looked as if it had been made of sugar and someone had licked it. (George Bernard Shaw on Isadora Duncan)

That's not writing; it's just typing. (Truman Capote on *On The Road*)

The paperback is very interesting but it will never replace a hardcover book as it makes such a poor doorstop. (Alfred. Hitchcock)

Reading a novel by Thomas Wolfe is like making love to a 300-pound woman: if she goes on top, you're asphyxiated. (Norman Mailer)

The only good thing about the theatre is that you can leave at the interval. (Philip Larkin)

Gertrude Stein was masterly in making nothing happen very slowly. (Clifton Fadiman)

Reading Joseph Conrad is like gargling with broken glass. (Hugh Leonard)

Denis Quilley played the role of Charles with all the animation of the leg of a billiard table. (Bernard Levin on Quilley's depiction of Charles Condamine in Noel Coward's *Blithe Spirit*)

There's no known cure for Kingsley Amis. (Robert Graves)

As a work of art, it has the same status as a long conversation between two not very bright drunks. (Clive James on Judith Krantz's novel *Princess Daisy*)

He's able to turn an unplotted, unworkable manuscript into an unplotted, unworkable manuscript with a lot of sex. (Tom Volpe on Harold Robbins)

Henry James turned his back on one of the great events in the world's history, the rise of the United States, in order to report tittle-tattle at tea parties in English country houses. (Somerset Maugham)

Murder is considered less immoral than fornication in literature. (George Moore)

Max Beerbohm is the only author whose reputation increases with every book he doesn't publish. (Somerset Maugham)

Truman Capote had a voice so high it could only be detected by a bat. (Tennessee Williams)

The way George Bernard Shaw believes in himself is very refreshing in these atheistic days when so many people believe in no God at all. (Israel Zangwill)

He hasn't an enemy in the world, but none of his friends like him. (Oscar Wilde on George Bernard Shaw)

What paper does he write for? (Yogi Berra after being asked if he knew Ernest Hemingway)

When I can't sleep, I read a book by Steve Allen. (Oscar Levant)

His more ambitious works may be defined as careless thinking carefully versified. (James Russell Lowell on Alexander Pope)

Lord Byron was always looking at himself in mirrors to make sure he was sufficiently outrageous. (Enoch Powell)

We had a perfect marriage until my wife found out the Book of the Month Club didn't hold meetings. (Bob Monkhouse)

The United States will never be a civilised country until we spend more money on books than we do on chewing gum. (Elbert Hubbard)

Every writer ought to have at least one thing he does well. Truman Capote's gift for publicity is the most glittering star in his diadem. (Gore Vidal)

Some poetry seems to have been written on typewriters by other typewriters. (Randall Jarrell)

Russian novels go on for about 942 pages. On page 920, Boris the peasant decides he wants to commit suicide, and you find yourself wishing he did it on page 4. (Frank McCourt)

There could only be two worse writers than Stephen Crane: that's two Stephen Cranes. (Ambrose Bierce)

The covers of this book are too far apart. (Ambrose Bierce)

POLITICS

In Congress a man gets up to speak; nobody listens to him, and then everybody disagrees. (Will Rogers)

We've got the kind of president who thinks arms control means some kind of deodorant. (Patricia Schroeder on Ronald Reagan in 1987)

I'm the master of low expectations (George W. Bush).

If Labour is the answer, it must have been a bloody silly question. (Graffito)

I know how hard it is for you to put food on your family. (George W. Bush)

Families is where our nation finds hope, where wings take dream. (George W. Bush)

Some reporters said I don't have any vision. I don't see that. (George W. Bush)

There's one sure way of telling when politicians aren't telling the truth – their lips move. (Felicity Kendall)

A leader who doesn't hesitate before he sends his nation into battle is not fit to be a leader. (Golda Meir)

A liberal is a man who'll give you everything he doesn't own. (Frank Dane)

George Washington never told a lie. I don't know how he ever made it in politics. (Bob Hope)

Politics is the art of looking for trouble, finding it whether it exists or not, diagnosing it incorrectly, and applying the wrong remedy . (Sir Ernest Benn)

McKinley has no more backbone than a chocolate eclair. (Theodore Roosevelt)

War is the national industry of Prussia. (Comte de Mirabeau)

George Bush was born with a silver foot in his mouth. (Ann Richards)

Clement Attlee reminds me of nothing more than a dead fish that hasn't had time to stiffen. (George Orwell)

Al Gore is in danger of being all things to no people. (Paul Bogart)

Did you hear that someone threw a bottle of beer at Bill Clinton? Fortunately it was draft so he was able to dodge it. (John Simmons)

When they call the roll in the Senate, the senators don't know whether to answer 'Present' or 'Not Guilty'! (Theodore Roosevelt)

Ronald Reagan must have loved poor people, because he made so many of them. (Edward Kennedy)

She probably thinks Sinai is the plural of sinus. (Jonathan Aitken on Margaret Thatcher)

If George Bush saw John Kerry walking on water he'd say 'I always knew he couldn't swim.' (Jay Leno)

As Moses, James Callaghan would have mistimed his arrival at the parting of the waters. (Austin Mitchell)

If Denis Healey were ill, the PLP would agree to send a get-well card by 154 votes to 127, with 28 abstentions. (Simon Hoggart)

He knows little about most things, and absolutely nothing about everything else. (Gerald Kaufman on Nicholas Edwards)

The only thing wrong with the Tory Party is the people who are in it. (John Lydon)

When you go to the dentist, he's the one who must need the anaesthetic. (Frank Dobson to Edwina Currie)

Putting Norman Tebbit in charge of industrial relations is like appointing Dracula to take charge of the blood transfusion service. (Eric Varley)

If you want Margaret Thatcher to change her mind you don't use argument. You look for a transplant surgeon. (John Edmonds)

If only I could piss the way Lloyd George speaks. (George Clemenceau)

George Boy is Dirty Harry without the gift of language. At the moment he's playing Spin-the-Bottle with a world map, chanting, 'Pick a country – any country'. (Roisin Gorman on George Bush after his invasion of Iraq in 2004)

Bill Clinton gets so much in speaking fees these days, if you say hello to him he replies, 'That'll be $10.' (Bob Dole)

At one time the British Secret-Service was staffed almost entirely by alcoholic homosexuals working for the KGB. (Clive James)

Politicians believe that any economic problem can be cured by opening a casino. (Scott Cohen)

The Speaker in Parliament looks like a demented transvestite poodle and can say nothing but 'Order, Order.' (Dave Allen)

I've met serial killers and professional assassins, but nobody ever scared me as much as Margaret Thatcher. (Ken Livingstone)

They say Al Gore is losing his hair. I hope not. That's the only part of him that moves now. (Jay Leno)

Harold Wilson is going round the country stirring up apathy. (William Whitelaw)

Neil Kinnock's speeches go on so long because he has nothing to say so he has no way of knowing he's finished saying it. (John Major)

A politician will always be there when he needs you. (Ian Walsh)

Talleyrand was a pile of shit in a silk stocking. (Napoleon)

There are too many men in politics and not enough elsewhere. (Hermione Gingold)

Tony Blair is the type of person who puts two poems into a bus shelter and calls it a university. (Victoria Wood)

The Tory Party is split into two factions over Nigel Lawson: those who hate him, and those who loathe him. (Ron Edmonds)

A politician is a fellow who will lay down your life for his country. (Texas Guinan)

Osama Bin Laden is either alive and well or alive and not too well or not alive. (Donald Rumsfeld)

It's a very good question and I'm not going to answer it. (George W. Bush)

I always had a weakness for foreign affairs. (Mae West)

Whenever you have an effective government, you have a dictatorship. (Harry S. Truman)

My early choice in life was either to be a piano player in a whorehouse or a politician. And to tell the truth, there's hardly any difference. (Harry S. Truman)

The Tory Party only panics in a crisis. (Ian McLeod)

There but for the grace of God goes God. (Winston Churchill on Stafford Cripps)

It's true that hard work never killed anybody, but I figured: why take the chance? (Ronald Reagan)

When the President does it, that means that it is not illegal. (Richard Nixon)

Neil Kinnock looks like a tortoise having an orgasm. (Patrick Murray)

When you are skinning your customers, you should leave some skin on to grow so you can skin them again. (Nikita Khruschev)

Richard Nixon told us he was going to take crime out of the streets. He did. He took it into the damn White House. (Ralph Abernathy)

I saw a headline which read 'Denis Healey caught with his pants down' and thought: that will make it easier to hear what he's saying. (Bob Monkhouse)

The world would not be in such a snarl, had Marx been born Groucho instead of Karl. (Irving Berlin)

A new Gallup poll asked 1,000 women if they would have sex with Bill Clinton. 70% said, 'Never again'. (Iain Dale)

We make fun of George Bush, but this morning he was at work bright and early. Okay – early. (Jay Leno)

When they circumcised Herbert Samuel they threw away the wrong bit. (David Lloyd George)

Kissinger brought peace to Vietnam in the same way Napoleon brought peace to Europe: by losing. (Joseph Heller)

Tony Benn immatures with age. (Harold Wilson)

Apart from that, Mrs Kennedy, how did you enjoy your trip to Dallas. (Graffito)

Receiving support from Ted Heath in a by-election is like being measured by an undertaker. (George Gardiner)

Tony Blair is just Margaret Thatcher with bad hair. (Boy George)

Reagan would have loved the Persian Gulf war. It was perfect. Bush tried to pass it off under the old agenda: 'We're going to war over human rights and oppression'. No. It was oil. If Kuwait's main export was white cotton socks, we wouldn't have been so quick to anger, would we? 'We've gotta save those socks, man! Summertime's comin up!' (Denis Leary)

Why are Nixon and Clinton alike? They were both brought down by Deep Throat. (Iain Dale)

Politicians are people who, when they see the light at the end of the tunnel, go out and buy some more tunnel. (John Quinton)

All these black people are screwing up my democracy. (Ian Smith)

It was so cold I saw a politician with his hands in his own pockets. (Henny Youngman)

One does wish that there were a few more women in parliament. Then one could be less conspicuous oneself. (Margaret Thatcher)

Prostitutes don't vote because they don't care who gets in. (Roy Brown)

Ted Heath is a shiver looking for a spine to run up. (Harold Wilson)

Inside I am twelve years old. That's why I've never voted. I'm under-age. (Sophia Loren on her 60th birthday in 1994)

Conservatives are not necessarily stupid, but most stupid people are conservative. (John Stuart Mill)

Why does George Bush have a clear conscience? Because it's never used. (Jay Leno)

If life were fair, Dan Quayle would be making a living asking, 'Do you want fries with that?' (John Cleese)

Ed Muskie talked like a farmer with terminal cancer trying to borrow on next year's crop. (Hunter S. Thompson)

What would you get if you offered George Bush a penny for his thoughts? Change. (David Letterman)

It's not enough for every intelligent person in the country voting for me. I need a majority. (Adlai Stevenson)

On hearing the news that Monica Lewinsky had given the President of the United States a blow job, a teenager asked, 'Mummy, what's a president?' (Nick Parker)

I was once asked how history might have been different if Khruschev was assassinated instead of Kennedy. I'll tell you one thing. I doubt Onassis would have married Mrs Khruschev. (Gore Vidal)

Bill Clinton didn't tell Monica Lewinsky to lie. He asked her to kneel. (Ian Hislop)

It makes no difference who you vote for. The two parties are really just one, representing 4% of the people. (Gore Vidal)

The Secret Service was under orders to shoot Dan Quayle if Bush was shot. (John Kerry)

Hillary Clinton is running for president in 2008. The reason? She wants to know what it's like to finally sleep in the president's bed. (Jay Leno)

I have a fantasy where Ted Turner is elected president but refuses because he doesn't want to give up power. (Arthur C. Clarke)

Richard Nixon can lie out of both sides of his mouth at the same time. If he ever caught himself telling the truth he'd lie just to keep his hand in. (Harry Truman)

Not only is he a bore: he bores for England. (Malcolm Muggeridge on Anthony Eden)

He occasionally stumbled over the truth, but hastily picked himself up and hurried on as if nothing had happened. (Winston Churchill on Stanley Baldwin)

The biggest mistake Bill Clinton ever made was not getting Teddy Kennedy to drive Monica Lewinsky home. (Denis Leary)

This is a great day for France. (Richard Nixon after touching down in Paris in 1974 before attending the funeral of former French President George Pompidou)

The main reason Ronald Reagan was elected Mayor of California was because he said that if he lost the election he would go back to acting. (Jack Lemmon)

Progress in the foreign Office is either vaginal or rectal. You either marry the boss's daughter or crawl up his backside. (Nicholas Monserrat)

Andrew Haig was a banality wrapped in a platitude inside a tautology. (Andrew Cooper)

What's the difference between Dan Quayle, Jane Fonda and Bill Clinton? Jane Fonda went to Vietnam. (John Simmons)

Bill Clinton's definition of safe sex is when Hillary is out of town. (Iain Dale)

You and your smarmy pundits and the smarmy pundits you have in your pocket can take your war and shove it. (Sean Penn to George Bush re the war in Iraq)

'I've been trying to work out,' said one of his civil servants, 'which has cost Britain more – the Second World War or Tony Benn.' (Anthony Sampson)

FOOT IN MOUTHS

Something that I was not aware had happened suddenly turned out not to have happened. (John Major)

Two things I can't stand – racism and blacks. (Graffiti)

Yesterday I thought I saw my brother on the street and he also thought he saw me, but when both of us got up close we realised it was neither of us. (Shane McCarthy)

I've told you hundreds of times before – stop exaggerating. (Dave Bannon)

I believe there would be people alive today if there were a death penalty. (Nancy Reagan)

So where's the Cannes Film Festival being held this year? (Christina Aguilera)

As I said to the Queen recently, I can't stand name-droppers. (Alan Whicker)

Instant gratification takes too long. (Carrie Fisher)

This is the 46th interview I've done about wanting privacy. (Glenda Gilson)

When I grow up I want to be a little boy. (Joe Heller)

This is the earliest I've ever arrived late. (Yogi Berra)

I never comment on referees and I'm not going to break the habit of a lifetime for that prat. (Ron Atkinson)

The only time they seem to get the ball is when they give it away. (Ian St. John)

One day the headmaster came into the room, looked at the day's numbers and said, 'Thirty-six present in the morning, only thirty-five in the afternoon. Stand up the one who's absent.' (John G. Muir)

I'm not superstitious – touch wood. (Dannie Abse)

I'm a psychic amnesiac. I know in advance what I'm going to forget. (Michael McShane)

Sixty is the age at which one starts to get young, but by then it's too late. (Pablo Picasso)

I'll never forget what's his name. (Leslie Wolfson)

I think that gay marriage should be between a man and a woman. (Arnold Schwarzenegger)

There's nothing the matter with being sick that getting well can't fix. (Peg Bracken)

I don't like funerals, In fact I may not even go to my own one. (Brian Behan)

I'll throttle the next person who accuses me of being violent. (Kevin McAteer)

We're now living in the age in which we live. (Ann Burdie)

My shoes are size 2½ – exactly the same as my feet. (Elaine Page)

I'll tell yon one fact. It may be boring, but it's rather interesting, (Barbara Cartland)

I bet I can make you give up gambling. (Anthony Bluett)

Anything that's violent in TV is a crime against humanity and they should shoot the head man responsible. (Ted Turner)

I'm for a stronger death penalty. (George Bush)

NON-SEQUITURS

Don't worry about the world ending today – it's already tomorrow in Australia. (Steven Wright)

Being powerful is like being a lady. If you have to tell people you are, you aren't. (Jesse Carr)

There are two times in a man's life when he should not speculate: when he can't afford it, and when he can. (Mark Twain)

We're overpaying him, but he's worth it. (Samuel Goldwyn)

Life is far too important to be taken seriously. (Oscar Wilde)

A smart girl is one who knows how to play tennis, golf, piano … and dumb. (Marilyn Monroe)

In my day there were things that were done and things that were not done. And there was even a way of doing things that were not done. (Peter Ustinov)

The man who gets on best with woman is the man who knows best how to get on without them. (Charles Baudelaire)

The great trick with a woman is to get rid of her while she thinks she's getting rid of you. (Soren Kierkegaard)

There is, of course, no reason for the existence of the male sex except that sometimes one needs help moving the piano. (Rebecca West)

Neil Simon didn't have an idea for a play this year but he wrote it anyway. (Walter Kerr)

I've always been a little more maturer than what I am. (Samantha Fox)

If you don't want your children to hear what you're saying, pretend you're talking to them. (Katharine Whitehorne)

I may not be known outside England but in London I'm world famous. (Graffiti)

I remember the elderly director who yelled at his young Method actor, 'Don't just do something, stand there'. (Anna Kashfi)

A bank is a place that will lend you money if you can prove that you don't need it. (Bob Hope)

I love all my children – but some of them I don't like. (Lillian Carter)

Our son kept our marriage together. Neither of us wanted custody of him. (Chubby Brown)

What you get free costs too much. (Jean Anouilh)

I may wear mink, but I think blue jeans. (Brigitte Bardot)

I worked my way up from nothing to a state of extreme poverty. (Groucho Marx)

Three things have helped me successfully through the ordeals of life – an understanding husband, a good analyst … and millions and millions of dollars. (Mary Tyler Moore)

It's not economical to go to bed early to save the candles if the results are twins. (Confucius)

Anyone who has ever struggled with poverty knows how devilishly expensive it is to be poor. (James Baldwin)

My mother's idea of economy was to take a bus ride to the Ritz (Lady Trumpington)

Take me or leave me. Or, as most people do, both. (Dorothy Parker)

A bank is a place where they lend you an umbrella in fine weather and then ask for it back again when it begins to rain. (Robert Frost)

When one has been threatened with a great injustice, one accepts a smaller one as a favour. (Jane Welsh Carlyle)

A woman without a man is like a fish without a bicycle. (Gloria Steinem)

The history of women is the history of the worst form of tyranny the world has ever known – that of the weak over the strong. (Oscar Wilde)

We went to Atari and said 'We've got this amazing thing.' They said no. Then we went to Hewlett-Packard. They said, 'We don't need you. You haven't got through college yet.' (Steve Jobs, the man behind Apple PC)

Only two things are necessary to keep one's wife happy. One is to, let her think she's having her own way, and the other is to let her have it. (Lyndon Johnson)

I may have faults, but being wrong ain't one of them. (Jimmy Hoffa)

The older we get, the better we used to be. (John McEnroe)

You can only predict things after they've happened. (Eugene Ionesco)

The trouble with that restaurant is that it's so crowded, nobody goes there anymore. (Steven Bauer)

It is human nature to think wisely and act foolishly. (Anatole France)

No doubt Jack the Ripper excused himself on the grounds that it was human nature. (A.A. Milne)

We learn from history that we do not learn from history. (Friedrich Hegel)

Basic research is what I'm doing when I don't know what I'm doing. (Bertrand Russell)

I have yet to see any problem, however complicated, which, when looked at the right way, does not become even more complicated. (Paul Anderson)

A diet is a system of starving yourself to death so you can live little longer. (Totie Fields)

When I don't feel well I drink and when I drink I don't feel well. (WC Fields)

Don't be humble. You're not that great. (Golda Meir)

Don't pay any attention to critics. Don't even ignore them. (Sam Goldwyn)

I have nothing to say and I'm saying it. That's poetry. (John Cage)

You have no idea what a poor opinion I have of myself and how little I deserve it. (W.S. Gilbert)

Man's dilemma is we hate change and love it at the same time. What we really want is for things to remain the same, but get better. (Sydney Harris)

If many remedies are suggested for a disease, it means the disease is incurable. (Raymond Chandler)

Self-love is so often unrequited. (Anthony Powell)

I seem to always run into strong women looking for weak men to dominate them. (Andy Warhol)

When a man brings flowers home to his wife for no reason, there's a reason. (James Simpson)

The reason I never take liquor is because I like it. (Stonewall Jackson)

I told the doctor I had a terrible stomach problem. She said, 'You have. It's bloody enormous.' (Jo Brand)

I've never been poor, only broke. Being poor is a frame of mind: being broke is a temporary situation. (Mike Todd)

To be clever enough to get money, one must be stupid enough to want it. (G.K. Chesterton)

Live within your income, even if you have to borrow to do so. (Josh Billings)

Gambling is the sure way of getting nothing for something. (Wilson Mizner)

I know a nudist who plays strip poker. Every time he loses he has to put something on. (Steven Wright)

Women who dress to please men should know that they don't have to dress to please men. (Mae West)

I wish I was what I used to be when I wished I was what I am. (Graffiti)

ADVICE

Wash your hands thoroughly. You never know where the soap's been. (Adrian Edmondson)

Whenever you're sitting across from some important person, always picture him in a suit of long red underwear. That's what I did, and why I was never intimidated in business as a result, (Joseph Kennedy)

Above all remember this: expect nothing and life will be velvet. (Eleanor Roosevelt)

The best way to fight is to get your retaliation in first. (Marion Brando)

Truth is the most valuable thing we have. Let us economise. (Mark Twain)

Never go to a plastic surgeon whose favourite artist is Picasso. (Gene Perret)

Revenge is a dish best served cold. (Arnold Bennett)

We women ought to put first things first. Why should we mind if men have their faces on the money as long as we get our hands on it? (Baker Priest)

If someone was stupid enough to offer me a million dollars to make a picture, I was certainly not dumb enough to turn it down (Elizabeth Taylor)

If you don't get what you like in life, like what you get. (G.K. Chesterton)

It's a good morning exercise for a research scientist to discard a pet hypothesis every day before breakfast. (Konrad Lorenz)

If you're going to be able to look back on something and laugh about it, you may as well laugh about it now. (Marie Osmond)

My mother always said, 'Don't marry for money. Divorce for money.' (Wendy Liebman)

If you don't go, you can't be late. (Anon)

The Centre for Disease Control reports that guns are now the second cause of premature death in America, just behind AIDS. So if you have unprotected sex, don't use a gun. (Johnny Robish)

If you want to keep something concealed from your enemy, do not disclose it to your friend. (Solomon Gabirol)

A woman should marry for love, and keep marrying until she finds it. (Zsa Zsa Gabor).

If you can't convince them, confuse them. (Harry Truman)

Do not fear when your enemies criticise you. Beware when they applaud. (Charles Bukowski)

Do unto others what they would do unto you, only worse. (Jimmy Hoffa)

Love your husband. Trust your husband. But get everything in your own name. (Joan Rivers)

If you're afraid of loneliness, don't marry. (Anton Chekhov)

The best way to remember your wife's birthday is to forget it once. (Desi Arnaz)

If you're going to write, write one poem all your life, let nobody read it, and then burn it. (Jack Nicholson)

On a first date, never ask for a *ménage a trois*. (Dylan Jones)

Always do sober what you said you'd do drunk. That will teach you to keep your mouth shut. (Ernest Hemingway)

Never prejudge the past. (Graffiti)

The best way to get rid of the noise in the car is to let her drive. (Brian Johnston)

If you want to be let off jury service, the word now goes, turn up with neat hair and tidy clothes. (Mary Kenny)

Accept good advice gracefully as long as it doesn't interfere with what you intended to do in the first place. (Gene Brown)

A businessman needs three umbrellas: one to have at the office, one to have at home and one to leave on the train. (Paul Dickson)

Never interrupt your enemy when he's making a mistake. (Napoleon Bonaparte)

Women should be obscene and not heard. (John Lennon)

Never pay attention to the critics. Don't even ignore them. (Sam Goldwyn)

If a million people follow you, ask yourself, 'Where did I go wrong?' (Indira Gandhi)

The best way to approach a girl with a past is with a present. (Hal Roach)

Never make a promise you can't break. (Gene Kerrigan)

If she looks old, she's old. If she looks young, she's young. If she looks back, follow her. (Bob Hope)

Don't let a man put anything over you except an umbrella. (Mae West)

If you can't open a childproof bottle, use pliers or ask a child. (Bruce Lansky)

You cant learn too soon that the most useful thing about a principle is that it can always be sacrificed to expediency. (W. Somerset Maugham)

If he asks 'Your place or mine?' say 'Both. You go to your place and I'll go to mine.' (Bette Midler)

The secret of eternal youth is to lie about your age. (Bob Hope)

MONEY

I've spent so much money on plastic surgery, it would have been cheaper to change my DNA. (Joan Rivers)

The problem with beauty is that it's like being born rich and getting progressively poorer. (Joan Collins)

The only reason to have money is to tell any sonofabitch in the world to go to hell. (Humphrey Bogart)

No, he takes 50% of everything I earn. (Elvis Presley's manager 'Colonel' Tom Parker after being asked if he took 50% of everything Elvis earned).

He could negotiate the gold out of people's teeth. (Beecher Smith on Parker).

Look at him – he'd want two million to read the nine o'clock news. (Trevor Howard watching Marlon Brando on the set of *Superman*, for which he was paid over £2 million for just a week's work).

No woman marries for money. They are all clever enough, before marrying a millionaire, to fall in love with him first. (Cesare Pavese)

Zsa Zsa Gabor once told me that she and Conrad Hilton, her millionaire ex-husband, had only one thing in common: his money. (David Niven)

I've got five dollars for each of you. (The alleged words of Hugo Goetz to the four muggers he shot on a New York subway in 1984 *a la* the Charles Bronson of *Death Wish*)

Monopoly is a terrible thing until you have it. (Rupert Murdoch)

I'm an honest enough sort of bloke. If you leave your wallet on the sofa in my house, it'll still be there when you come back for it. Most of the money will have gone, and all the credit cards, but the wallet will still be there. (Chris Tarrant)

I don't want to die a millionaire: just to live like one. (Walter Hagen).

My doctor said I looked like a million dollars – all green and wrinkled. (Red Skelton)

Remember the poor. It costs nothing. (Josh Billings)

To park your car in London's Soho costs 20p for three minutes. That's £4 an hour. There are people working in McDonalds in Soho who can look out the window and see parking meters earning more than they are. (Simon Evans)

The price of Prozac went up 50% last year. When users were asked about it, they just went, 'Whatever…' (Conan O'Brien)

I wonder why you can always read a doctor's bill and never his prescription. (Finley Peter Dunne)

What good is the moon if you cannot buy or sell it. (Financier Ivan Boesky)

Technically, Bill Gates is the nineteenth richest country in the world. He should change his name to Bilgaria. (Rich Hall)

That guy would bottle your pee and sell it for a fiver. (Ringo Starr on Jeffrey Archer after attending a charity fundraiser hosted by Archer)

Did you hear about the Alabama man who died and left all his money to his widow? She can't touch it till she's 14. (Dan Fenwick)

Misers aren't fun to live with, but they make wonderful ancestors. (David Brenner)

My wife didn't marry me for my money. She married me for my father's money. (Nicky Hilton)

One day Bob Mitchum was complaining to me about how much his son was costing him. I said, 'Bob, I hate to tell you this, but it's normal for a father to finance his son.' Bob said, 'When he's forty years old?' I said, 'Bob, you just won the argument'. (Michael Winner)

If all the rich people in the world divided up their money among themselves, there wouldn't be enough to go around. (Christina Stead)

A little hush money can do a lot of talking. (Mae West)

Not only do I love her – I worship the ground her father struck oil on. (Ronnie Barker)

The only thing I like about rich people is their money. (Nancy Astor)

Millionaires are marrying their secretaries because they're so busy making money they haven't time to see other girls. (Doris Lilly)

I think I've figured out why Bob Geldof is so interested in the poor. He looks like one of them. (Ricky Gervais)

I know I can't take it with me, but will it last until I go? (Martha Newmayer)

No one would ever have remembered the Good Samaritan if he'd only had good intentions; he had money as well. (Margaret Thatcher)

Bill Gates visited India the other day just so as he can feel even richer. (Conan O'Brien)

He's so mean he wouldn't let his little baby have more than one measle at a time. (Eugene Field on an acquaintance)

When shit becomes valuable, the poor will be born without assholes. (Henry Miller)

Mother always said that honesty was the best policy and money isn't everything. She was wrong about other things too. (Gerald Barzan)

He's so old that when he orders a three-minute egg, they ask for the money upfront. (Milton Berle)

A rich man is one who isn't afraid to ask the salesman to show him something cheaper. (Anon)

Just about the time you think you can make both ends meet, someone moves the ends. (Pansy Penner)

Did you hear about the Scotsman who split his wage packet down the middle every Friday? His wife got the packet and he got the money. (Bob Monkhouse)

Gentlemen prefer bonds. (Andrew Mellon)

PEOPLE AND PLACES

I once thought about killing myself, but went to Belgium instead. (Stephen Fry)

The English have The English have three vegetables, and two of them are cabbage. (Walter Page)

You can tell Australian hamburgers by the way the meat starts eating the lettuce. (Johnny Carson)

I didn't like L.A. The people were rude, I nearly got arrested for smoking in a bar, I was frequently tapped for money by beggars on Venice Beach, a Groucho Marx T-shirt cost $200, and the waiters and waitresses were all out-of-work actors full of bullshit. (Roy 'Chubby' Brown)

I like Florida. Everything is in the eighties: the temperature, the ages, the IQs… (George Carlin)

Mussolini shot yesterday and hung upside down in the street and spat at. The Italians are a lovable race. (Noel Coward diary entry in 1945)

It's part of Ireland's national inferiority complex that when someone pays us a compliment we take it as an insult. (Michael Noonan)

I left England when I was four because I found out I could never be King. (Bob Hope)

Let's be frank. The Italians' technological contribution to humankind stopped with the pizza oven. (Bill Bryson)

Home advantage counts for little in Luxembourg soccer matches. The corners have to be taken from well inside Belgium. (Andy Lyons)

I don't like. Norway. The sun never sets, the bar never opens, and the whole country smells of kippers. (Evelyn Waugh)

Americans will go on adoring me until I say something n ice about them. (George Bernard Shaw)

Argentina is a true democracy. Everybody eventually becomes president. (Joe Duffy)

Ireland is a figment of the Anglo-Saxon imagination. (Brendan Behan).

The reason there is so little crime in Germany is because it's against the law. (Alex Levin)

I've got a friend who's half-Polish and half Jewish. He's a janitor, but he owns the building. (Jackie Mason)

I was thinking about the Blarney Stone recently. Only the Irish could persuade people to kiss an edifice the Norman soldiers had urinated on. (Dave Allen)

The Jews invented guilt and the Irish turned it into an art form. (Walter Matthau)

If England treats her criminals the way she has treated me, she doesn't deserve to have any. (Oscar Wilde)

In Tulsa the restaurants have signs that say, 'Sorry. we're open'. (Roseanne)

The worst winter I ever spent was one summer in San Francisco. (Mark Twain)

I reckon no man is thoroughly miserable unless he be condemned to live in Ireland. (Jonathan Swift)

The English always have their wars in someone else's country. (Brendan Behan)

'A man who is tired of London is tired of life'? No, I was tired of hunting for parking spaces. (Paul Theroux)

Are you Indian or Pakistani? I can never tell the difference between you chaps. (Prince Philip)

The newspapers were too thick and the lavatory paper too thin. (Winston Churchill after visiting New York)

There are only two classes of good society in England: the equestrian classes and the neurotic classes. (George Bernard Shaw)

The Jewish Mafia is called Kosher Nostra. (Graffito)

The Irish people do not gladly suffer common sense. (Oliver St. John Gogarty)

Other people have a nationality. The Irish and the Jews have a *psychosis*. (Brendan Behan)

MUSIC

The main difference between Michael Jackson and Bill Clinton is that Michael Jackson tries to convince us he's had sex with women. (David Letterman)

It's a measure of how bad things are that Eminem is the height of outrage. What's so outrageous about being the cultural equivalent of a school bully? (Boy George)

There were 45 people at Bob Geldof's last concert in Rome. You'd get more people than that in the loo at a Westlife gig. (Louis Walsh)

Drew Barrymore sings so badly, deaf people refuse to watch her lips move. (Woody Allen)

The first act of *Parsifal* occupied two hours and I enjoyed that, apart from the singing. (Mark Twain)

By the end of his life, Elvis had turned into an Elvis impersonator. (Tara McAdams)

Movie music is noise. It's even more painful than my sciatica. (Sir Thomas Beecham)

Compare the music of *The Beggar's Opera* with that of a contemporary revue. They differ as the Garden of Eden differed from life in the artistic quarter of Gomorrah. (Aldous Huxley)

Having adapted Beethoven's Sixth-Symphony for *Fantasia*, Walt Disney commented, 'Gee, this'll make Beethoven.' (Marshall McLuhan)

The last Rolling Stones tour grossed more than the Gross National Product of Guyana, and had a worse human rights record. (Alexei Sayle)

Geri Halliwell can't sing, can't dance, and by the look of things can't hold down a meal either. (Gina Yashere)

A fiddle is an instrument to tickle human ears by the friction of a horse's tail on the entrails of a cat. (Ambrose Bierce)

One Russian is an anarchist. Two are a chess game. Three are a revolution and four the Budapest String Quartet. (Jascha Heifetz)

Never pay attention to the critics. Nobody ever put up a statue to one of them. (Jean Sibelius)

Puccini wrote marvellous operas but dreadful music. (Dmitri Shostakovich)

I don't mind what language an opera is sung in so long as it is one I don't understand. (Sir Edward Appleton)

The music business has all the sincerity of a whore's kiss. (Sinead O'Connor)

There's a pecking order for celebrities at after-show parties. One time both Prince and Madonna circled a block in their

limos for twenty minutes because neither of them wanted to be the first to arrive. (Boy George)

I had a nightmare that I was trapped in an elevator with Geri Halliwell and Bryan McFadden and I had only one bullet in my gun. (Mark Lamarr)

Buzz Aldrin, tell me the truth: were you really mad when you were beaten to the moon by Louis Armstrong? (Ali G)

My mother used to pray I would get cancer of the throat. (Maria Callas)

I was the only director who ever made two pictures with Marilyn Monroe. Forget the Oscars. I deserve the Purple Heart. (Billy Wilder)

Cliff Richard has love bites on his mirror. (Geoff Hyams)

You have to admire Madonna. She. hides her lack of talent so well. (Manolo Blahnik)

Pop music is the kind that's played so fast you can't work out which classical composer it was pinched from. (Michael Harkness)

I love Dolly Parton. I don't know why. Maybe it's a subconscious desire to breastfeed. (Graham Norton)

Michael Jackson dances as if he's being electrocuted. Dream on. (Milt Green)

Don't confuse fame with success. One is Madonna, the other Helen Keller. (Erma Bombeck)

We live in a country where John Lennon takes six bullets in the chest. Yoko Ono is standing right next to him. Not one fucking bullet. Explain that to me. (Denis Leary)

Michael Jackson is doing a record with his brothers to prove that white people *can* work with blacks. (Conan O'Brien)

Back in the eighties I was seen as the benchmark queer because I was the one plastered in make-up with androgynous clobber. George Michael passed for a straight stud but in fact it was he who was loitering around in bushes and public loos like some pre-war homosexual. (Boy George)

Music is an accessory, not an object. To worship it is akin to worshipping wallpaper. (H.G. Wells)

The only sanction contemplated against Israel is forcing them to take part in the Eurovision Song Contest. (George Galloway)

Boy George can't make up his mind if he wants to work with Robbie Williams or beat him up. (Ian O'Doherty)

Jerry Springer said his show was garbage. Then they made an opera about it. That says it all. (Esther Rantzen)

What's the difference between a rock star and a terrorist? You can negotiate with a terrorist. (Madonna)

Let's be easy on Eminem. At the end of the day he's just another white guy trying to make an honest living stealing black people's music. (Comic Dog)

A musicologist is a person who can read music but can't hear it. (Sir Thomas Beecham)

Most people wouldn't know good music if it came up and bit them on the ass. (Frank Zappa)

Electric guitars are an abomination. Whoever heard of an electric violin? An electric cello? Or for that matter an electric singer? (Andres Segovia)

Old session musicians never die, they just fake away. (Steve Ellis)

I'm sitting at the opera and thinking: Look how much work it takes to bore me. (Dave Atell)

Beethoven's music is music about music. (Friedrich Nietzsche)

Even before the concert music begins, there is that bored look on people's faces: a polite form of self-imposed torture. (Henry Miller)

The first requirement for a composer is that he be dead. (Arthur Honegger)

When the batteries run down on my Walkman, Bob Dylan still sounds the same. (Lance Crowther)

Ozzy Osbourne was invited to the White house to meet President Bush. Just goes to show that if you do a lot of controlled substances and talk like a three-year-old you can go really far in America. And Ozzy's doing okay too. (Greg Proops)

Some of the songs making the rounds now will be popular when Bach, Beethoven and Wagner are forgotten – but not until then. (Louis Sobel)

I believe Luciano Pavarotti has had surgery on his neck. The hardest part of the operation, according to the surgeon, was finding it. (Conan O'Brien)

Her singing was something between the sound of a rat drowning, a lavatory flushing, and a hyena devouring her afterbirth in the Appalachian mountains under a full moon. (Auberon Waugh)

RELIGION

Everyone says forgiveness is a lovely idea until they have something to forgive. (C.S. Lewis)

The disciples often said to Jesus, 'Stop turning water into wine, I'm trying to take a shower'. (Steven Wright)

The problem with writing about religion is that you run the risk of offending sincerely religious people, and then they come after you with machetes. (Dave Barry)

I read the other day that Jehovah's Witnesses don't celebrate Halloween. I guess they don't like strangers coming up to their door and annoying them. (Bruce Clark)

The priest at my school used to follow us to dances. He'd come between me and the girl I was dancing with and say, 'You have to keep this far apart' as he indicated his ruler. Presumably he was imagining my penis to be the same size. I always thought he was an incredible optimist. (Dave Allen)

I got suspended from Catholic school. At an eighth grade dance I was told I was dancing too close to a girl. Father said; 'Leave a little room for the Holy Ghost.' I replied, 'Are you kidding? After what he did to Mary? (Atom)

The Pope said Easter Mass in 57 different languages. And that was just for New York City cab drivers. (David Letterman)

Jesus saves, but then he's not on PAYE. (Graffiti)

If God was condemned to live the life he has inflicted on others, he would kill himself. (Alexander Dumas)

Many people feel they're attracted to God when they're merely repelled by man. (W.R. Inge)

Catholics commit more sins than any other religion, but get less fun out of it. (Woody Allen)

If God hadn't intended us to gamble, he would never have given us money. (Zsa Zsa Gabor)

Flying is where I always re-discover my faith. All those prayers you learned as a child suddenly come in very useful on take-off, landing, and when turbulence rears its ugly head at 30,000 feet. (Eamonn Holmes)

Sometimes I think war is God's way of teaching us Geography. (Paul Rodriguez)

What do you get when you cross a Jehovah's Witness with an atheist? Someone who knocks on your door for no apparent reason. (Guy Owen)

Why is it that we never hear Christian athletes mentioning God's name when they lose? (George Carlin)

The crucifixion was just one of those parties that got out of hand. (Lenny Bruce)

You can tell a lot about someone's personality if you know his star sign. Take Jesus. Born December 25, fed the 5,000, walked on water – typical Capricorn. (Harry Hill)

I don't want to go to heaven if you have to stand all the time. (Spike Milligan)

A priest says to a man on his deathbed, 'My son, do you renounce the devil and all his teachings?' The dying man replies, 'With all respect, Father, this is really not the time to be making enemies.' (Dave Allen)

Isn't it remarkable that all the worst crimes of republican violence have been committed immediately after Mass? (Ian Paisley)

I'm not a fatalist, but even if I were, what could I do about it? (Emo Philips)

If God had really been in favour of decimalisation, there would only have been ten disciples. (Sean Gaffney)

She was an atheist and I was an agnostic. We didn't know what religion *not* to bring up our children in. (Woody Allen)

Men don't get cellulite, which confirms my belief that God is, after all, male. (Rita Rudner)

Samson died from fallen arches. (James McKeon)

The Church of England is rather like British Rail. I can't bring myself to rely on it. (Norman Tebbit)

Why is it that when we talk to God we're said to be praying, but when God talks to us, we're schizophrenic? (Lily Tomlin)

God gives us our relatives – thank God we can choose our friends. (Ethel Watts Mumford)

In the beginning there was nothing. God said 'Let there be light' and there was light. There was still nothing, but you could see it a whole lot better. (Ellen DeGeneres)

Bono was an atheist until he realised he was God. (Nay McLachlan)

The peculiar tragedy of Belfast lies not in the fact that its citizens hate each other, but that they do so in the name of Christ. (Dr James Scott)

God is like a Jewish waiter: he has too many tables. (Mel Brooks)

I always felt sorry for Jesus, being born on Christmas Day and all that. He missed out on a Christmas present. (Michael Redmond)

Christ died for our sins. Dare we make his martyrdom meaningless by not committing them? (Jules Feiffer)

The hottest places in hell are reserved for those who in time of great moral crises maintain their neutrality. (Dante Alghieri)

I do benefits for all religions. I don't want to blow the hereafter on a technicality. (Bob Hope)

I'm still an atheist, thank God. (Luis Bunuel)

If Moses had been a committee, the Israelites would still be in Egypt. (J.B. Hughes)

Jesus must have been incredibly patient. As a teenager he had these incredible powers and he never abused them. If I had these powers at seventeen I'd be walking on water backward, naked, with a 13-inch erection going 'Hey girls, look at this! Free wine for everybody!' (Denis Leary)

The only difference between Catholics and Jews is that Jews are born with guilt and Catholics have to learn it in school. (Elayne Boosler)

The Vatican is against surrogate mothers. Good thing they didn't have that rule when Jesus was born. (Elayne Boosler)

David Koresh thought he was Jesus. I don't believe it. There can't be three of us. (Al Rae)

CHILDREN

What is more enchanting than the voices of young people when you can't hear what they're saying? (Logan Pearsall Smith)

The secret of being a good parent is not to look at your child for the first three years after it's born. (Ernest Hemingway)

Physically there is nothing to distinguish human society from the farmyard except that children are more troublesome and costly than chickens. (George Bernard Shaw)

Children are a great comfort in your old age. They also help you to reach it faster. (Lionel Kauffman)

There are two classes of travel: first class and with children. (Robert Benchley)

When I was a boy of 14 my father was so ignorant I could hardly stand to have the old man around, but when I got to 21 I was astonished at how much he had learned in seven years. (Mark Twain)

It's no wonder people are so horrible – they started life as children. (Fisher Ames)

My mother never saw the irony in calling me a son of a bitch. (Jack Nicholson)

The modern child, when asked what he learned at school, replies, 'Nothing, but I gained some meaningful insights.' (Bill Vaughan)

Far better to have loved and lost than to have to buy shoes for eight kids. (William Walton)

The main trouble with children is that they're not returnable. (Quentin Crisp)

I lived in a normal family: I had no love for my father. (Joe Orton)

I don't like the little bastards. I like to hear the patter of little feet going away from me – especially two houses away. (Raymond Chandler)

Parents are the bones on which children sharpen their teeth. (Peter Ustinov)

I had a job training dogs before I became a teacher. It was a good preparation. (Frank McCourt)

You can't expect a boy to be vicious till he's been to a good school. (Saki)

It's customarily said that Christmas is done 'for the kids'. Considering how awful Christmas is and how little our society likes children, this must be true. (P.J. O'Rourke)

To watch a child drowning a few yards away from me has a dispiriting effect on my appetite. (Harry Graham)

Never raise your hand to your children – it leaves your midsection unprotected. (Robert Orben)

Being born is like being kidnapped … and then sold into slavery. (Andy Warhol)

Children are a bit like farts. People tend to like their own ones. (Graham Norton)

I am fond of children, except boys. (Lewis Carroll)

The only saving grace of being at boarding school was freedom from my mother's cooking. (Spike Hughes)

We had a quicksand box in our backyard, I was an only child, eventually. (Steven Wright)

I've got two wonderful children. Well, two out of five ain't bad. (Henny Youngman)

There are only two things a child will share willingly: communicable diseases and his mother's age. (Benjamin Spock)

Look at Patty Hearst. Those parents of hers cutting those peanut butter sandwiches day after day just to turn her into an urban guerrilla. (Barry Humphries)

Insanity is hereditary: you get it from your children. (Hal Roach)

Any man who hates little children and small dogs can't be all bad. (W.C. Fields)

Many people prefer children to dogs. Principally, I think, because a licence is not required for the former. (Harry Graham)

There is much to be learnt from that piece of advice printed on most bottles of patent medicine: 'Keep Away From Small Children'. In fact I always have. (Denis Norden)

Permissiveness is the principle of treating children as if they were adults – and the tactic of making sure they never reach that stage. (Thomas Szasz)

The denunciation of the young is a necessary part of the hygiene of older people, and greatly assists the circulation of the blood. (Logan Pearsall Smith)

I hate babies. They remind me too much of monkeys. (Saki)

Men are generally more careful of the breed of their horses and dogs than of their children. (William Penn)

The first half of our lives is ruined by our parents and the second half by our children. (Clarence Darrow)

I can't abide children. It was merely pretence on my part to get round their mothers and so spend an idle hour with them. (J.M. Barrie)

I don't like kids. It's not just that they're smelly and noisy, but unfortunately you have to be in the same room as them or they'll hurt themselves. (Sean Hughes)

Setting a good example for your children takes all the fun out of middle age. (William Feather)

My childhood was a period of waiting for the moment when I could send everyone and everything connected with it to hell. (Igor Stravinsky)

Until I grew up thought I hated everybody, but then I realised it was just children I abhorred. (Philip Larkin)

We've had bad luck with our kids – they've all grown up. (Christopher Morley)

THE LAW

I've spent a number of unforgettable days of my life standing in corridors adjacent to courtrooms, surrounded by 3 or 4 lawyers, each of whom I was paying the equivalent of a month's salary to stand around telling me bad jokes. For considerably less than I was paying these jokers I could have flown Billy Connolly on a chartered Concorde to entertain me in my home. (John Waters)

Lawyers are the only people whose ignorance of the law isn't punished. (Lord Brougham)

An appeal is when one court is asked to show its contempt for another one. (Finley Peter Dunne)

The prosecution had so much incriminating evidence, they were like little children on Christmas morning who just couldn't figure out which package to open first. Yet once the packages were opened, they played with only a few of the toys. (Policeman Mark Fuhrman on the OJ Simpson case)

If we lawyers only took cases in which we really believed, we'd go out of business in no time. (Henry Cecil)

Lawyers have a favourite expression: 'He lies like an eyewitness.' (Don Murray)

If you can understand a contract, it must be legally unsound. (Lambert Jeffries)

Our court systems are just swamps of dark and devious jargon. It's just a wash of dull, crippled, masked wordage

put before a jury of twelve imbeciles or a bored judge. (Charles Bukowski)

You might as well employ a boa constrictor for a tape measure as to go to a lawyer for legal advice. (Oliver St. John Gogarty)

Judges are no more moral than garbage collectors, nor less free of prejudice. (A.S. Neill)

An airplane full of lawyers was hijacked by terrorists. They promised to release one every hour unless their demands were met. (Denis Leary)

Everybody who has ever said, 'Talk to my lawyer' put down the phone and thought to himself, 'Oh shit'.' (Pete Ferguson)

I have come to regard the law court not as a cathedral but rather as a casino. (Richard Ingrams)

I don't hire a lawyer to tell me what I cannot do. I hire him to tell me how to do what I want. (J.P. Morgan)

A jury is a group of twelve people of average ignorance. (Herbert Spencer)

A lawyer is someone who rescues your money from your enemies and keeps it for himself. (Lord Brougham)

The law is like a woman's knickers – full of dynamite and elastic. (John B. Keane)

The judge sentenced me to 100 hours of community work with the mentally disadvantaged. I asked him if that included the time I spent in court. (Emo Philips)

Irritable judges suffer from a bad case of premature adjudication. (John Mortimer)

A lawyer's dream of heaven – every man reclaimed his property at the resurrection, and each tried to recover it from all his forefathers. (Samuel Butler)

My attorney is brilliant. He didn't bother to graduate from law school. He settled out of class. (Milton Berle)

If I wrote about honest lawyers I wouldn't be able to give my books away. (John Grisham)

My daddy is a movie actor. Sometimes he plays the good guy and sometimes he plays the lawyer. (Malcolm Ford, son of Harrison)

A man calls his lawyer and asks, 'How much would you charge me to answer three questions? '$400,' says the lawyer. The man says, 'That's a lot of money, isn't it?' And the lawyer replies, 'It is. Now what's your third question?' (Milton Berle)

CUNNING LINGUISTS

I think, therefore I'm single. (Liz Winston)

Ask not what you can do for your country, for they're liable to tell you. (John Steinbeck)

Lead me not into temptation; I can find the way myself. (Rita Mae Brown)

There's a story on the children's page of a trade union journal which begins, 'Once upon a time and a half...' (Andy Lacker)

If the pen is mightier than the sword, in a duel I'll let you have the pen. (Steven Wright)

Nice guys finish last. What's wrong with that? Isn't that what most women want? (Bob Ettinger)

If brevity is the soul of wit, your penis must be a riot . (Donna Gephart)

One man's mate is another man's passion. (Eugene Healy)

Serendipity means looking for a needle in a haystack and finding a farmer's daughter. (Auberon Waugh)

Discretion is not the better part of biography. (Lytton Strachey)

My life has been a case of wine, women and so-long. (Dean Martin)

They say you can't take it with you. Well if that's the case, I'm not going. (Jack Benny)

No one thinks there's much ado about nothing when the much ado is about themselves. (Anthony Trollope)

Time is the best teacher. Unfortunately, it kills all the students. (Franklin P. Jones)

If absolute power corrupts absolutely, does absolute powerlessness make you pure?

The pen is mightier than the sword. And considerably easier to write with. (Marty Feldman)

Silence isn't always golden. Sometimes it's guilt. (Sydney Findlater)

Look twice before you leap. (Charlotte Bronte)

It takes two to make a marriage, but only one to break it. (Herbert Samuel)

Alimony is the screwing you get for the screwing you got. (Humphrey Bogart)

New Year's Eve is where old acquaintance be forgot – unless the tests come back positive. (Jay Leno)

It's the overtakers who keep the undertakers busy. (William Pitts)

A gentleman is a man who wouldn't hit a woman with his hat on. (Fred Allen)

Keep a diary and one day it'll keep you. (Mae West)

Make love not war. Or else marry and do both. (Graffiti)

Keep London tidy: eat a pigeon (Graffiti)

Life is a sexually transmitted disease. (Graffiti)

Love thy neighbour – but make sure his wife doesn't find out. (Graffiti)

Will you take this woman to be your awful wedded wife? (Dylan Thomas)

Always be sincere, whether you mean it or not. (Sam Goldwyn)

Save energy: get cremated with a friend. (Graffiti)

Everyone has a right to my opinion. (Louis B. Mayer)

You cannot shake hands with a clenched fist (Indira Gandhi)

An apple a day keeps the doctor away. An onion a day keeps everyone away. (Graffiti)

French dockers rule au quai. (Colin Jarman)

Actions lie louder than words. (Carolyn Wells)

An Irish atheist is a man who wishes to God he could believe in God. (Graffiti)

Those who can, do. Those who can't, teach. And those who can't teach become PE instructors. (Woody Allen)

Bureaucracy defends the status quo long after the quo has lost its status. (Laurence J. Peter)

Marriages are made in heaven, but so is thunder and lightning. (Clint Eastwood)

Breast implants make mountains out of molehills. (Zero Mostel)

Save a boyfriend for a rainy day – and another in case it doesn't. (Mae West)

It's pretty hard to tell what brings happiness, considering poverty and wealth have both failed. (Kin Hubbard)

You're still young if the morning after the night before still makes the night before worth the morning after. (Bob Goddard)

Time may be a great healer, but it's no beauty specialist. (Herbert Prochnow)

After shaking hands with a Greek, count your fingers. (Albanian saying)

I dress for women, and undress for men. (Angie Dickinson)

Let us all live within our means, even if we have to borrow to do so. (Artemus Ward)

Any girl who swears she has never been made love to has a fight to swear. (Sophia Loren)

A hard man is good to find. (Mae West)

Don't accept lifts from strange men. And all men are strange. (Robin Morgan)

Don't knock masturbation. It's sex with someone I love. (Woody Allen)

Show me a good loser and I'll show you a loser. (Paul Newman)

When things just can't get any worse, they will. (Arthur Bloch)

A bird in the Strand is worth two in Shepherd's Bush. (Spike Milligan)

Behind every successful man stands a surprised mother-in-law. (Hubert Humphrey)

Confucius him say: Man who take girl in park have peace on earth. (Graffiti)

Bigamy proves that two rites make a wrong. (Phil Kelly)

In politics, it rarely pays to be wise before the event. (Chris Patten)

If all the girls at Vasser were laid end to end, I wouldn't be at all surprised. (Meryl Streep)

Living in the past has one thing in its favour: it's cheaper. (Alan Bennett)

The wise man thinks once before he speaks twice. (Robert Benchley)

Man does not live by words alone, despite the fact that he often has to eat them. (Adlai Stevenson)

If you want to pull the wool over your wife's eyes, you need a good yarn. (Gyles Brandreth)

Apples are so expensive these days, you may as well have the doctor. (Henny Youngman)

There was a time when a fool and his money were soon parted, but now it happens to everyone. (Adlai Stevenson)

If it ain't broke don't fix it – unless you're a politician. (Denis Leary)

You can't make a Hamlet without breaking egos. (William Goldman)

In the spring a young man's fancy turns to things he's been thinking about all winter. (Hal Roach)

Money talks. Mine said goodbye. (Henny Youngman)

Money doesn't talk, it swears. (Bob Dylan)

Do unto others that which you do not wish them to do unto you. (James Huneker)

Women. Can't live with them, can't live with them. (Don Rickles)

My philosophy of working out is simple: no pain, no pain. (Carol Liefer)

A verbal contract isn't worth the paper it's written on. (Sam Goldwyn)

If the shoe fits, buy it in every available colour. (Imelda Marcos)

If you can keep your head when all about are losing theirs, you probably don't understand the problem. (Jean Kerr)

Two can live as cheaply as one … for half as long. (Howard Kandel)

The only original thing about some men is original sin. (Helen Rowland)

Man has created God in his image. (George Santayana)

Say it with flowers. Hit him over the head with a bouquet. (Roseanne)

ART

You couldn't miss Andy Warhol: a skinny creep with his silver wig. He said he wanted to be as famous as the Queen of England. Here was this weird cooley little faggot with his impossible wig and his jeans and his sneakers and he was sitting there telling me he wanted to be as famous as the Queen of England. It was embarrassing. I thought he was lucky that anybody would talk to him, never mind make him famous. (Frederick Eberstadt)

Whistler has always spelt art with a capital 'I'. (Oscar Wilde)

The best way to tell if a modern painting is completed is to touch it. If the paint is dry, it's finished. (Hal Roach)

Andy Warhol was the only genius with an IQ of 60. (Gore Vidal)

Did you for one moment imagine that all you had to do was to paint a can of soup 81 times life-size and straight away you would rule the world and be co-starred in a movie with Mrs Burton? (Quentin Crisp to Andy Warhol)

Occasionally I feel he lacks something which carries him beyond himself, i.e. a heart that beats. (Paul Gauguin on Edward Degas)

I doubt that art needed Ruskin any more than a moving train needs one of its passengers to shove it. (Tom Stoppard)

Andy Warhol's serial photo silkscreens of Marilyn Monroe are about as sentimental as Fords coming off the assembly line. (Ron Sukenick)

His pictures seem to resemble, not pictures, but a sample book of patterns of linoleum. (Cyril Asquith on Paul Klee)

Monet began by imitating Manet, and Manet ended by imitating Monet. (George Moore)

Why don't you leave them to an asylum for the blind? (Andrew McNeil Whistler to an art patron who considered donating his paintings to an institution)

Modern art is a square lady with three breasts and a guitar up her crotch. (Noel Coward)

Salvador Dali decided to have a one-man show, which he did. It was a great success. One man showed up. (Woody Allen)

He will lie even when it's inconvenient – a sign of the true artist. (Gore Vidal)

You scarcely knew if you were looking at a parcel of nude flesh or a bundle of laundry. (Jules Claretie on Edouard Manet)

If I met Picasso in the street I would kick him in the pants. (Sir Alfred Munnings)

A successful artist would have no trouble being a successful member of the Mafia. (Sir Sidney Robert Nolan)

Another word from you and I'll paint you as you are. (Artist Max Liebermann to a garrulous subject)

If I like a painting I say it's mine. If I don't, I say it's a fake. (Pablo Picasso)

If Botticelli were alive today he'd be working for *Vogue*. (Peter Ustinov)

Abstract art is a product of the untalented, sold by the unprincipled to the utterly bewildered. (Al Capp)

A decorator tainted with insanity. (Kenyon Cox on Gauguin)

Turner's painting *The Slave Ship* resembles a tortoiseshell having a fit in a plate of tomatoes. (Mark Twain)

When I took my children to see some of Henry Moore's abstract sculptures in Hyde Park, my daughter Laura said at one point, 'Look, something's fallen off a Jumbo jet.' (Spike Milligan)

Anyone who paints a sky green and pastures blue ought to be sterilised. (Adolf Hitler)

A highbrow is someone who looks at a sausage and thinks of Picasso. (A. P. Herbert)

LOVE

Love is generally valued at its highest during two periods in life: during the days of courting and the days in court. (Lee Marvin)

What's romance? Usually a nice little tale where you have everything As You Like It, where rain never wets your jacket and gnats never bite your nose and it's always daisy-time. (D.H. Lawrence)

Love is never having to say you're sorry. Marriage is never having a chance to say anything (Hal Roach)

Love is the most subtle form of self-interest. (Holbrook Jackson)

Because women can do nothing but love, they've given it a ridiculous importance. (Somerset Maugham)

It's in our thirties that we want friendship. By the forties we realise that won't save us any more than love did. (F Scott Fitzgerald)

Love is what you feel for a dog or a pussycat. It doesn't apply to humans. (Johnny Rotten)

Love is just another four letter word. (Tennessee Williams)

What's the difference between herpes and true love? Herpes lasts forever. (Graffito)

Love is a game of secret stratagems in which only the fools who are fated to lose reveal their true motives. (Eugene O'Neill)

What is love? The need to escape from oneself. (Baudelaire)

There's no such thing as love. Take a romantic couple to Ethiopia, where there's no food, and they'll eat each other. (Howard Stern)

Self-love seems so often unrequited. (Anthony Powell)

When you're in love it's the most glorious 2½ hours of your life. (Richard Lewis)

Of all forms of caution, caution in love is the most fatal to true happiness. (Bertrand Russell)

The love that lasts longest is the love that's never returned. (W. Somerset Maugham)

Love is just a system for getting someone to call you 'darling' after sex. (Julian Barnes)

What is commonly called love is merely the desire of satisfying a voracious appetite with a certain quantity of delicate white human flesh. (Henry Fielding)

This is the nature of women, not to love when we love them, and to love when we love them not. (Cervantes)

When my love swears she is made of truth, I do believe her, though I know she lies. (William Shakespeare)

Love as a relation between men and women was ruined by the desire to make sure of the legitimacy of children. (Bertrand Russell)

Better to have loved and lost than to have paid for it and not enjoyed it. (Graffiti)

I wanted to marry her ever since I saw the moonlight shining on the barrel of her father's shotgun. (Eddie Albert)

The less we love a woman, the more we are loved by her. (Alexander Pushkin)

One should always be in love. That is the reason one should never marry. (Oscar Wilde)

Perhaps at 14, every boy should be in love with some ideal woman to put on a pedestal and worship. As he grows on, of course, he will put her on a pedestal the better to view her legs. (Barry Norman)

Love is two minutes and 52 seconds of squishing noises. (Johnny (Rotten)

A love affair nowadays is a tableau of two wild animals, each with its teeth sunk in the other's neck, each scared to let go in case it bleeds to death. (Kenneth Tynan)

In their first passions women are in love with their lover; in all the rest, with love. (La Rochefoucauld)

Love begins with a prince kissing an angel. It ends with a bald-headed man looking across the table at a fat woman. (Rodney Dangerfield)

Much of what we call love is in fact mutually indulged laziness. (Kenneth Tynan)

I fell in love with her smile but married the rest of her too. Drat. (W.C. Fields)

A man can be happy with any woman as long as he does not love her. (Oscar Wilde)

Because women can do nothing but love, they've given it a ridiculous importance. (Somerset Maugham)

I knew I was falling in love with her because I read it every day in the newspapers. (Eddie Fisher in wry mood about his courtship of Debbie Reynolds)

Greater love than this no man hath but that he lays down his wife for his friend. (James Joyce)

I love Mickey Mouse more than any woman I've ever known. (Walt Disney)

There are three types of men in the world: the loving, the faithful, and the majority. (Richard Jeni)

My wife and I thought we were in love but it turned out to be benign. (Woody Allen)

Michael Redgrave is in love with himself but he's not sure if it's reciprocated. (Anthony Quayle)

I'm not into that one-night thing. I think a person should get to know someone and even be in love with them before you start to use and degrade them. (Steve Martin)

Love is a temporary insanity curable by marriage. (Ambrose Bierce)

AGE

Mickey Rooney has to live to be 100 so he can pay the alimony he owes all those ex-wives. He's not *allowed* to die. (George Burns)

I'm pleased to be here. Let's face it, at my age I'm pleased to be anywhere. (Ronald Reagan)

On my 70th birthday I hung a black wreath on my door. (Bette Davis)

Yes, I'd consider going out with women my age — if there *were* any. (George Burns at 92)

I've been around so long I knew Doris Day before she was a virgin (Groucho Marx)

I have my 87th birthday coming up and people are asking me what I'd like for it. I always answer, a paternity suit. (George Burns)

If you survive long enough you're revered – rather like an old building. (Katharine Hepburn)

Advanced old age is when you sit in a rocking chair and can't get it going. (Eliakim Katz)

When I started in show business, the Dead Sea was only sick. (George Burns)

Inside every 70-year-old is a 35-year-old saying 'What happened?' (Ann Landers)

Old age is the happiest time in a man's life. The trouble is, there's so little of it. (W.S. Gilbert)

My age is 39 plus tax. (Liberace)

I was born in 1962. The room next to me was 1963. (Joan Rivers)

I have no views. When one is retired it is sensible to refrain from having views. (Joseph Alsop)

For a while you're venerable; then you're just old. (Lance Alworth)

It's not how old you are, it's how hard you work at it. (Jonah Barrington)

Old age is always 15 years older than what I am. (Barnard Baruch)

The trouble is, you're not allowed to grow old in the world anymore. (Tony Hancock)

As long as you can still be disappointed, you're still young. (Sarah Churchill)

Old age isn't so bad when you consider the alternative. (Maurice Chevalier)

Old age takes away what we've inherited and gives us what we've earned. (Gerald Brennan)

Youth is a disease from which we all recover. (Dorothy Fuldheim)

In a dream you are never 80. (Anne Sexton)

The worst thing anybody ever said about me is that I'm 60. Which I am. (Joan Rivers)

You can calculate Zsa Zsa Gabor's age by the rings on her fingers (Bob Hope)

If you live to be 100 you've got it made. Very few people die past that age. (George Burns)

I know I'm going to die because my birth cert has an expiry date on it. (Steven Wright)

Pushing forty? On the contrary, she's clinging onto it for dear life! (Ivy Compton-Burnett of an acquaintance)

Middle age is when work is a lot less fun, and fun is a lot more work. (Milton Berle)

40 is the first time you realise you can't do it the second time. 50 is the second time you realise you can't do it the first time. (Mort Sahl)

I refuse to admit I'm more than 52 even if that makes my sons illegitimate. (Nancy Astor)

Middle age is when everything new you feel is likely to be a symptom. (Laurence J. Peter)

When women pass thirty, they first forget their age. When forty, they forget that they ever remembered it. (Ninon de Lenclos)

The great comfort of turning 40 is the realisation that you are now too old to die young. (Paul Dickson)

Actresses over 40 can generally kiss goodbye to their film careers in Hollywood, but an actor can go on to nearly double that. (Meryl Streep)

Every man over 40 is a scoundrel. (George Bernard Shaw)

Ageing seems to be the only known way to live a long time, unfortunately. (Daniel Auber)

An archaeologist is the best husband any woman can have. The older she gets, the more interested he is in her. (Agatha Christie)

After 40 a woman has to choose between losing her face or her figure. My advice is to keep your face and stay sitting down. (Barbara Cartland)

It's just as well to be told you're too old at 40: then you're over it. (Grace Murney Hooper)

No, it's not great being over 50. In fact it's like going to the guillotine. (Angie Dickinson)

Women over 40 are at their best, but men over 30 are too old to realise that. (Jean-Paul Belmondo)

Middle age is when you bend down to tie your shoelace, and then wonder if there's anything else you can do while you're down there.

One of the hardest decisions in life is wondering when to start middle age. (Clive James)

Thirty is a nice age for a woman – especially if she happens to be forty. (Phyllis Diller)

At 40 a woman is just about old enough to start looking younger. (Katharine Whitehorne)

When I was 40 my doctor advised me that a man in his forties shouldn't play tennis. I heeded his advice carefully and could hardly wait until I reached 50 to start again. (Hugo Black)

I'm at the age where my back goes out more than I do. (Phyllis Diller)

We were so poor my mother couldn't afford to have me so the woman next door gave birth to me. (Mel Brooks)

I was born in Alabama but I only lived there for a month before I'd done everything there was to do. (Paula Poundstone)

If newborns could remember and speak, they would emerge from the womb carrying tales as wondrous as Homer's. (Newsweek, 1982)

She reaches her age by light years – she's sure light a few years. (Henny Youngman)

I was born at the age of twelve on the MGM lot. (Judy Garland)

I'm pleading with my wife to have birthdays again. I don't want to grow old alone. (Rodney Dangerfield)

GRAFFITI

Pornography offers a vice to the lovelorn.

Sailors always ensure there's a port in every wife.

Irishmen love everybody – you have been warned.

Don't shout at me – I'm not your mother.

I got married in curlers because I wanted to look good for the reception.

I'm very happily divorced.

Women are the weaker sex – but men are the weakest.

Mary had a little lamb … her case comes up next week.

Everybody lies, but it doesn't matter since nobody listens.

History doesn't repeat itself; historians merely repeat each other.

No matter where you go, there you are.

The one day you'd sell your soul for something, souls are a glut.

Never attribute to malice that which is adequately explained by stupidity.

Don't worry about the menopause – worry about the ones who don't.

I thought innuendo was an Italian suppository until I discovered Smirnoff.

You can use a pill to get rid of a headache … and vice versa.

Married men make the best husbands.

A woman who's smart enough to ask a man's advice isn't dumb enough to take it.

It's easy to lie with a straight face – but more fun with a curved body.

Masochists just do it for kicks.

If you don't believe in the virgin birth you're labouring under a misconception.

Little Red Riding Hood is a Russian Contraceptive.

All feminists should be put behind bras.

Sex is the only game which becomes less interesting when played for money.

Virgins whisper sweet-nothing-doings into your ear.

A man can tell what kind of time he had at the party by the look on his wife's face.

Incest is the theory of relativity.

Sexy women are like spiders: they lead to the flies undoing.

Massage parlours are for people who knead people.

A bisexual is a person who likes women as much as the next man.

Gynaecologists are just spreaders of old wives' tails.

A woman is never too old to yearn.

Marriage should be grounds for divorce.

Save energy : make love slowly.

Puberty is a hair-raising experience.

My girlfriend is the sort of lass you could take home to mother … if you could only trust father.

Be creative – invent a perversion.

There's only one difference between sex for money and sex for free: sex for free costs more.

Sex Appeal: give generously.

If it wasn't for pickpockets I'd have no sex life at all.

Love is a many-gendered thing.

Seduction is the art of genital persuasion.

The penis is mightier than the sword.

Circumcision is a bloody rip-off.

FREE WOMEN! Where ?

Marriage is the process of discovering the kind of woman your husband would have preferred.

Better to have loved a small man than never to have loved a tall.

Sex Appeal: give generously.

Veni, Vidi, VD.

Ah well, at least life is only temporary.

A PENN'ORTH OF ALLSORTS

We couldn't afford laxatives when I was young. Our father used to sit us on the po and tell us ghost stories. (Big O)

My cross in life is arthritis, but I don't talk about it. Most people are bored by your problems. My father always told me that the phrase 'How are you?' is a greeting, not a question. (Maeve Binchy)

There is no end to the violations committed by children on children, quietly talking alone. (Elizabeth Bowen)

I reckon we're all made up of equal parts Rambo and Lucille Ball. (Boy George)

Granny said she was going to grow old gracefully, but she left it too late. (Christine Kelly)

'If you don't go to school and lean your lessons,' Brian Moore's mother told him, 'you'll be good for nothing but opening car doors and holding umbrellas over old ladies.' (Patricia Craig)

I became a father last Saturday. My immediate future will doubtlessly be a never-ending series of clean-ups, nappy changes and conversations about the colour of babies' bowel movements. (Olaf Tyaransen)

The only way to avoid being miserable is not to have enough leisure to wonder whether you're happy or not. (George Bernard Shaw)

My sister's first dramatic outburst occurred the day my mother tried to change her diaper. (Christopher Fitzsimons on Maureen O'Hara)

I heard a charity appeal on the radio the other day that said it only takes ten euros a week to support a child in Africa. I'm thinking of moving my whole family out there. (Patrick Donovan)

One must not dislike people because they're intransigent. That would only be playing their own game. (Louis MacNeice)

My mother was hostile towards my wife. She thought the sun shone from her boy's derriere. If I'd brought home the Virgin Mary, she'd have said her family wasn't good enough. (George Hook)

Gay Byrne never forgot he was always on camera so that even if you were boring the arse off the man he would give you that look suggesting you made Einstein seem like a dummy. (Lee Dunne)

It's minorities that change the world. (Terry Wogan)

Never share a foxhole with someone braver than you are. (Dennis Fitzpatrick)

Life is what happens whilst we are making other plans. (Fr Brian D'Arcy)

A pier is a disappointed bridge. (James Joyce)

My only belief in life is that if you dish out shit, rest assured that you will get shit back to you. (Kevin Kelly)

The less you do, the less mistakes you make. (Bernie Comaskey)

There's only one problem about instant gratification: it takes too long. (Oven O'Neill)

I went to the doctor and he told me I was suffering from hypochondria. 'Not that as well!' I said. (Jimmy O'Dea)

We are born at the rise of the curtain and we die with its fall, and every night in the presence of our patrons we write our new creation, and every night it is blotted out forever. So what use is it to say to audience or critic: 'Ah, but you should have seen me last Tuesday'. (Micheal Mac Liammoir)

Life is perhaps most wisely regarded as a bad dream between two awakenings. (Eugene O'Neill)

There are three kinds of people: Those who can count and those who can't. (George Carlin)

Experience isn't interesting till it begins to repeat itself. In fact it is hardly experience till it does that. (Elizabeth Bowen)

Publicity can't be switched off. There's always someone hiding in the bushes. (Ronan Keating)

Surgeons' mistakes get buried, architects' ones get built. (Ruairi Quinn)

They spent £6 million on The Spike. What's the point? (Mary Mannion)

If only 60% of people believe all statistical statements presented to them are true, does that mean only 60% will also only believe this one I'm writing now? (Fran Dempsey)

Life is a mess. We don't remember being born, and death isn't an experience, so all we have is this chaotic middle bit, bristling with loose ends, in which nothing is ever properly finished or done with. (John Banville)

The day after tomorrow is the third day of the rest of your life. (George Carlin)

I understand life isn't fair, but why couldn't it just once be unfair in my favour? (Christy Murphy)

The most embarrassing moment of my life was when a caller told me on live radio that I had a voice like honey dripping on nipples. (Brenda Power)

A lighthouse has no function in the daytime. (Sr Stanislaus Kennedy)

My father wasn't very well educated. The first time he saw Brussels Sprouts he said, 'Who made a balls of the cabbage?' (Big O)

We can no more learn from another than we can do their death for them. (John McGahern)

Television contracts the imagination. Radio expands it. (Terry Wogan)

Anyone can sympathise with the sufferings of a friend, but it takes a fine nature to sympathise with a friend's success. (Oscar Wilde)

There's no gaiety as gay as the gaiety of grief. (Caitlin Thomas)

The only things one never regrets are one's mistakes. (Oscar Wilde)

Swearing is a compromise between fighting and running away. (Finley Peter Dunne)

We begin to live when we conceive life as a tragedy. (W.B. Yeats)